CW00558521

THE WEST HIGHLAND EXTENSION

John McGregor

AMBERLEY

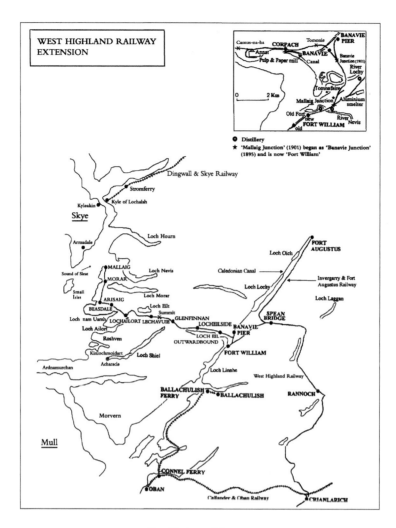

For Chris and Renata

First published 2013

Amberley Publishing
The Hill, Stroud
Gloucestershire, GL5 4EP

www.amberley-books.com

Copyright © John McGregor, 2013

The right of John McGregor to be identified as the
Author of this work has been asserted in accordance
with the Copyrights, Designs and Patents Act 1988.

ISBN 978 1 4456 1338 3
E-Book ISBN 978 1 4456 1350 5

British Library Cataloguing in Publication Data.
A catalogue record for this book is available from
the British Library.

Typeset in 9.5pt on 12pt Celeste.
Typesetting by Amberley Publishing.
Printed in the UK.

Introduction

The West Highland Mallaig Extension sprang from the Banavie branch, on which traffic began in June of 1895 – it was then the only appendage of the West Highland line, opened to Fort William the previous August. 'Mallaig Junction' was once 'Banavie Junction' and, renamed a second time, has become 'Fort William'. The town signal box disappeared some forty years ago, along with the pier-head station, and the goods yard and engine shed at the old fort. Though the branch is largely lost, a reminder endures in the River Lochy viaduct; its lattice girders are clearly of a kind with the many viaducts on the West Highland proper.

The West Highland Bill of 1888–9 included an arm from Spean Bridge to the Caledonian Canal at Gairlochy, rousing the suspicions of the Highland Company. The West Highland promoters and their North British backers disavowed any early intention of advancing to Inverness, and the proposed branch was deleted. However, the Highland could tolerate a West Highland link with the waterway at its southern end, where passenger boats turned in Banavie basin, above the bank of locks called Neptune's Staircase. A horse omnibus shuttled summer tourists between Banavie and Corpach, where the Oban steamers terminated. From 1895 they could disembark at Fort William, taking the train to Banavie for their onward journey to Inverness. Through coaches (sometimes through trains), Glasgow–Banavie and Banavie–Glasgow, ceased from 1901. The Extension, bridging the Canal below the locks, had its own 'Banavie' and the original station became 'Banavie Pier'.

Friends insisted (foes grudgingly conceded) that the West Highland route should be continued to the western seaboard. The Mallaig Extension Bill of 1893–4 had a long gestation (below) but a relatively easy passage. All depended, however, on state assistance. Only in 1896 was the formula fixed – a dividend, guaranteed (in effect, topped-up) by the Treasury, on a large slice of capital; an outright grant for Mallaig harbour; and relief from local authority rates. The Light Railways Act that same year was a complication, strengthening the case for a less expensive line.

A railway paralleling Telford's early nineteenth century road to Arisaig suggested itself to Victorian engineers (though Arisaig bay was not a suitable harbour). In 1884 the Napier Commission, investigating distress and unrest in the Highlands, concluded that a third railway port, additional to Oban and Strome Ferry, ought to be established, 'north of Ardnamurchan ... south of Strome'. A 'government line' all of 80 miles long, from Tyndrum on the Callander & Oban or Kingussie on the Highland, through Lochaber to the Inverness-shire coast was 'unthinkable'; but assistance, after the event, for any railway reaching Fort William would be justified, aiding its prolongation to the western sea. The commissioners had in mind the Glasgow & North Western Railway of 1882–3, blatantly speculative and rejected by Parliament. Facing defeat, the promoters of this ambitious 160-mile line to Inverness had offered to recast it as a railway to Fort William and 'the Arisaig coast'.

In 1889 the House of Lords struck from the West Highland Bill an 'extension' to Roshven on Loch Ailort. Landlord opposition was not the only reason. The West Highland promoters depended utterly on the North British Company, whose guarantee for the moment went no further than Fort William. The Roshven line, which ostensibly met the Napier criteria, was tacked on to win sympathy for the main West Highland project and to stake a claim for future aid. With the West Highland under construction (1889–94) and assistance for railway

development in Ireland a talking point, the Government were obliged to frame a policy. The Lothian Commission (1889–90) and ensuing Treasury Committee (1890–1) addressed the transport needs of the Highlands and Islands. But further development of the West Highland route was not assured. While Roshven still had supporters, Mallaig bay was now the preferred goal, a more costly proposition. Those who recognised Mallaig's limitations wanted the yet more expensive option of a commodious and better sheltered harbour well inside Loch Nevis. Moreover there were other contenders for state assistance, especially the Garve & Ullapool Railway, authorised in 1890.

The Conservatives (Unionists), in office until 1892, reluctantly accepted that two new railways were needed. The 'north of Strome' candidates were all in the territory of the Highland Company, who wanted the Mallaig scheme abandoned – it was the only serious contender 'south of Strome' – as a condition of cooperation. The Liberal Government of 1892–5 felt no urgency. Many of their backbenchers saw subsidy as helping only the railway interest and their landed allies. (One MP took the opportunity to attack the North British monopoly of Fife and mistreatment of his Kirkcaldy constituents. Condemning his obstruction, a protest meeting at Fort William burned his effigy.) The final compromise eliminated all 'north of Strome' options, the Garve & Ullapool included. Balancing the Mallaig Guarantee, a grant would carry the Highland Company's Dingwall & Skye line from Strome Ferry to Kyle of Lochalsh, the terminus intended back in the 1860s; more traffic would flow through Oban, thanks to the steamer subsidies prescribed in the Lothian Report. Thus the North British Company, the Highland and the Caledonian (working the Callander & Oban Railway) would all gain something. But North British shareholders needed persuading that, with government assistance in place, a finite outlay would secure the contributory traffic of the Extension, reducing the burden which the West Highland had already become.

The 'Loch Eil & Mallaig Railway' first took shape in 1890, when landowner Baird of Knoydart sponsored a new survey on his own account. Cameron of Lochiel (a promoter and director of the West Highland) feared that the chance of subsidy would slip away. He had helped unite the landlords behind the West Highland Bill in 1888–9, and he now initiated negotiations, engaging the Treasury, the Scottish Office and the North British board. A late bill might have won through in 1893 but the Government were not accommodating. The ponderously titled West Highland Railway Mallaig Extension Act passed in 1894, just as the West Highland was completed to Fort William. There were congratulatory, optimistic speeches at the West Highland's official opening, and the Liberals at last confirmed the Conservative pledge of assistance. But the necessary legislation hung fire; opposition persisted; and the Conservatives (back in office from 1895) insisted on the strict terms first offered. Many months would pass before construction of the Extension (1897–1901) could begin.

By the 1890s 'Crofter-Liberal' MPs were entrenched in constituencies across the Highlands; they favoured new railways but distrusted landowners. Lochiel and his allies came under pressure to demonstrate their commitment to the Mallaig Extension, acknowledging how their own estates would benefit. The proprietors who had resisted the Roshven scheme came aboard, joining earlier campaigners. Lord Lovat, though identified with the Highland Company, gave the land needed at Mallaig. Landowner influence of course persisted. Locheilside station would be sited well away from Craigag Lodge. Lochailort station was to be invisible from Inverailort House. The Inverailort family, who complained of likely injury to their fishing and stalking

preserves and pressed for a deviation at Loch Eilt, were placated with a 'daylight only' halt for shooting parties at Lechavuie. Lord Howard of Glossop, though his steamer on Loch Shiel obtained financial support from the North British, was averse to the expansion of summer tourism.

The Extension was entrusted to Simpson & Wilson, earlier commissioned by Baird of Knoydart. Alexander Simpson was judged 'safe' (he would become a North British director) – unlike Charles Forman of Formans & McCall, engineer of the West Highland and eager for new projects. However, the Mallaig railway (i.e. the Roshven line as might have been) is essentially Forman's to Kinlochailort, including the summit tunnels; and Mallaig's combined breakwater and pier derives from his design for Roshven. (We may imagine a Forman lattice-girder viaduct describing the great curve at Glenfinnan.) Onwards to Mallaig, the conservative Simpson laid out the best possible conventional line – cuttings, embankments, viaducts and more tunnels. To avoid tunnelling, Forman would have accepted even fiercer gradients, employing rack-and-pinion.

Lucas & Aird, who built the West Highland to Fort William and Banavie, expected the Extension contract. It was a disqualification that, like Forman, they kept a speculative eye on the Great Glen, where the North British could not control events. Successful bidder Robert McAlpine used mass concrete on an unprecedented scale – in the major viaducts at Glenfinnan, Loch-nan-Uamh, Borrodale and Morar; in such smaller examples as Polnish (Arnabol) and Larichmore; and in numerous lesser structures, accommodation works and station buildings. Concrete was not a new medium and Forman had favoured it at certain locations on the West Highland proper (e.g. in the footings of Glen Falloch viaduct). But the Extension was 'all concrete' (in fact, plate girders formed two low-set bridges, near Drumsallie and by Loch Eilt) and Borrodale viaduct had the largest concrete arch yet attempted.

The Mallaig line cannot match the West Highland's inland sweep by Breadalbane and Rannoch, with ascents to summits above 1,000 feet. It makes what in gentler country might be termed 'hops' – from Loch Eil by Glenfinnan and Loch Eilt to Loch Ailort; then to Loch-nan-Uamh; and thence to Arisaig. The North British stipulated that the Extension be no more exacting than the Craigendoran–Fort William line. But the gradients are severe, the curves extremely tight. Keppoch Moss, beyond Arisaig, has 'floating' embankments (like those on Rannoch Moor). Though tunnels total eleven, only the Borrodale bore is of any length. Most were planned as cuttings, but tunnelling proved easier. Bad weather and intractable rock (which, crushed, made aggregate for concrete) prolonged the work. Passing stations on the Extension had side-platforms and roomy signal boxes, in contrast to the island stations and dwarf cabins on the original West Highland. The simple Extension buildings, in modified 'chalet' style, kept a family resemblance. Dispensing with station footbridges, the Board of Trade made a nod towards 'light' operation.

Compressed-air drills brought a modern touch. (Lucas & Aid used a few steam shovels on the earlier contract.) Concrete-shuttering skills were in demand. Materials came largely by sea. Temporary works over the Caledonian Canal were constrained, and the swing bridge at Banavie was completed last of all. The North British ruefully noted that the independent Invergarry & Fort Augustus Railway, connecting with the West Highland at Spean Bridge and begun, like the Extension, in 1897, generated more construction traffic than the Mallaig line.

Why the North British went adventuring in the western Highlands is debatable, though rivalry with the Caledonian and the prospect of a new route to Inverness certainly enter.

The Mallaig Extension was completed in a new era of rising costs and other pressures, when coexistence overtook competition and amalgamations were in prospect. Board-room upheavals punctuate North British history, and the regime which saw in the twentieth century wanted economy and no new obligations. Traffic began, without ceremony, on 1 April 1901. The passenger provision later familiar – through trains between Glasgow and Mallaig, reversing in Fort William, and a supplementary local service – was not at first envisaged. Some workings offered through coaches; and the local coach-sets comprised rigid-wheelbase stock, not the superior bogie vehicles introduced on the West Highland in 1894. With little general goods traffic, mixed trains were common.

Mallaig was at first chaotic and, in part, squalid, despite a new hotel and a sturdy tenement for railwaymen. Surplus land was let haphazardly to curers, porters and casual workers. The original water supply was inadequate. (During an exceptional heat-wave, improvised tankers ran from Fort William.) Unflattering reports (e.g. a steam-crane driver with enteric fever) did harm, and the Caledonian Company proclaimed Oban's superior facilities. By 1910 the public health authorities were threatening intervention. Improvement had already begun, but too late for the ideal solution, a working harbour with a planned village inland towards Morar. Though penny-pinching blighted the first years of the Mallaig line, the North British, finally absorbing the West Highland Company from 1908, made some improvements. They would not entertain enlargement of Mallaig harbour, within a costly outer breakwater. No further government money was on offer. The Treasury Guarantee (running till 1931) lost its value under 'De-Control' when the First World War was over. After the Grouping the LNER reviewed Mallaig's potential and suggested, without result, that the state contribute to harbour improvement in proportion to spending on trunk roads.

Adequate as a centre for short-range sail boats, Mallaig coped erratically with multiplying steam trawlers and drifters. Overcrowding in season alternated with slack periods. Goods trains took cured fish. For fresh and 'sprinkled' (lightly salted) fish, specials ran as required, and fish vans were routinely added to passenger trains (which complicated reversal and re-marshalling at Fort William). Fish specials and the corresponding empties taxed the capacity of the West Highland route, but not so impossibly that additional passing places became absolutely necessary. A fish-traffic pool embracing Kyle of Lochalsh, Mallaig and Oban might have emerged from wartime 'Control' but in the event the Grouping gave the west coast very largely to the LMS, with Mallaig a lone LNER outpost.

For seventy years vessels of the MacBrayne fleet connected with West Highland trains at Mallaig. Their replacement by roll-on, roll-off ferries signalled changing times. Though David MacBrayne's near monopoly, underpinned by mail contracts and 'Lothian' subsidy (above), was resented, expectations that the North British would sponsor a rival were unrealistic. In practice the steamer routes out of Kyle, Mallaig and Oban were complementary not competitive. The Loch Shiel vessel (ultimately another MacBrayne service) linked Acharacle with Glenfinnan, where a 'horse lorry' took luggage, post and small cargo between pier and train. Mail for Moidart and Ardnamurchan via the West Highland and Loch Shiel was mail lost to the Callander & Oban, and Caledonian attempts to recover it echoed, in a small way, the 'railway wars' of earlier days.

Loading banks along the Mallaig Extension, though basic, were 'sufficient for horse-and-carriage traffic'. Besides the needs of local proprietors, the August-to-October 'season' still mattered. House parties travelled first-class across the Border and around the Highlands; there

were servants and luggage, and also equipment for shooting and fishing. But by 1914 motoring had already reduced railway income from this source; for the late-coming West Highland route, it could not be a long-term standby. Livestock traffic lasted until the 1950s. Itinerant dealers were outmoded and Fort William quickly acquired an auction mart. Sale days needed specials, first for Brae Lochaber (Glen Spean) and then for the Mallaig line. As a market town in the wider sense, Fort William looked to recover ground lost to Oban during the 1880s, following completion of the Callander & Oban Railway and reorganisation of the connecting steamers. But the miles across Rannoch Moor had little to offer, and Saturday locals for Glen Spean were soon discontinued. (By the 1920s Spean Bridge and Roy Bridge were served by bus.) However, communities along the Extension made Fort William their centre. And the primitive road west of Corpach long precluded serious bus competition.

Older children travelled to Fort William Secondary School (now Lochaber High School) – in later years by the up 'mixed' from Mallaig, which preceded the morning Mallaig-Glasgow. They returned by the late afternoon down local. While Fort William's twice-yearly town holidays merited specials to Glasgow and Glasgow routinely provided excursion stock, specials on the Extension were ad hoc – for the Lochaber Mod, say, or a shinty cup final, or Glenfinnan Highland Games... Lochaber Cooperative Society (founded by railwaymen) organised employees' outings by train, perhaps to Arisaig or Morar. Railway life on the 40-mile Extension had its own quality too. Families at several locations on the West Highland proper lived in bleak isolation; along the Mallaig line crofting could be combined with railway work – as surfaceman, guard, or even (in diesel days) engine-driver.

Extra summer trains on the Extension at first ran three days a week, a measure of pre-1914 demand for day excursions, while leisurely tours of the Highlands remained in vogue for those of adequate means – tours which often included the all-day passage of the Caledonian Canal aboard a MacBrayne paddle steamer. Between the wars, Canal tourism declined, and with it the Banavie branch; passenger services ended in 1939. Meanwhile the Extension had acquired a relatively intensive summer timetable, geared to days out, as paid holidays for the wider population increased. This pattern resumed after the Second World War, peaking in the 1950s, with sailings from Mallaig (on Loch Shiel and Loch Ailort too) tied to the trains. A runabout ticket (with Spean Bridge and Roy Bridge thrown in) gave a week's unlimited travel. Besides day returns, Fort William offered yet cheaper afternoon and evening returns all along the Mallaig line.

From 1933 the Northern Belle, comprising day and night portions, gave week-long 'cruises' of the LNER's scenic districts every summer. When the day coaches of this all-mod-cons hotel-train made the round trip on the Extension, the train paused on Glenfinnan viaduct for the view down Loch Shiel (a practice now revived). Post-1945 austerity told against the Belle's re-introduction but an enterprising initiative (1956) was the deployment of the ex-LNER Coronation observation cars, first on the Extension and then on the West Highland proper. Such was their popularity that the timetable was adjusted, allowing two Fort William–Mallaig return journeys daily. The mid-morning (summer only) Glasgow–Mallaig brought the other car north, to be removed at Fort William, where the Extension car was then attached for its second down journey – altogether an operation, not forgetting change of engines, which tested the restricted layout to the limit.

From 1901 the under-powered, frequently piloted, West Highland Bogie 4-4-0s took up Extension duties. Intermediates (from 1906) and Glens (from 1914) subsequently proved their

worth; the former, though not so well remembered, lingered long on the Extension. 2-6-os were introduced by the LNER; and the Mallaig line remained 2-6-0 (LNER K2s, K4s and K1s, and BR Standard 3s, in order of arrival) when 4-6-os became established on Glasgow–Fort William service. 0-6-os were employed from the first, doing passenger work too. Dedicated to the West Highland but stressed by fast running along the Clyde, the K4s gave way to B1s and Black 5s for Glasgow–Fort William work; on the Extension they continued, through the 1950s, to handle heavy trains unassisted.

In its first forty years the Mallaig line changed little. Protection at Banavie swing-bridge was simplified. Additional unstaffed halts, to light-railway standard, were sought but not conceded. Read today, the well-subscribed petition for a platform at Polnish only testifies to population loss, which the railway did not prevent and probably accelerated. A siding for Loch-nan-Uamh was not pursued when the landowner allowed small consignments of fish to be handled at Beasdale station, at first semi-private. In fact the crofter-fisherman was not readily professionalised; local fishings at Loch-nan-Uamh and elsewhere steadily declined, while Mallaig as a fishery centre grew after a fashion (above). The railway carried catches to the cities; brought barrels, fuel, salt and seasonal labour; and attracted auction and curing businesses. But the all-round benefits expected from better transport were not achieved – and historians will continue to debate the case for a 'social railway' propounded by the Napier Commission.

In 1917–8 American materials for the wartime northern barrage were landed at Corpach and transhipped via the Canal to Invergordon, occasioning a curious support working, with two reversals en route, between Corpach and Fort Augustus. The Second World War, when the entire region west of the Canal became a Protected Area, made a greater impact – Inverailort had a Special Services establishment; Corpach (new sidings) and Annat (new loop and siding at Camus-na-ha) had a large naval presence. Lechavuie platform found a new role, as Commandos and other troops exercised in the Rough Bounds. The Admiralty store ships anchored in Loch Eil would remain, eerie shadows on a moonlit night, for several post-war years.

The Banavie branch closed completely in 1951. From the mid-1950s, bit-by-bit improvement of the A830 commenced in earnest, with ominous implications. BR's Scottish Region met the immediate disruption by improvising an Extension 'motorail' – prosaically, a car-carrier van attached to designated up trains. At Fort William, as in horse and carriage times, it was shunted to the old fort loading bank. Long before the modern road was complete, lorries had secured much of the traditional fish traffic. (That in the late twentieth century the herring shoals would desert the west coast was, from the railway view point, just a post-script to decline.) The general expansion of road transport doomed the mail steamers (above) and brought on construction of the Isle of Skye Bridge, superseding the Kyleakin ferry and leaving the Mallaig–Armadale link less important. That the Highland Railway at Kyle of Lochalsh and the North British at Mallaig once contemplated (albeit reluctantly) the building of ferry-connected light railways across Skye is a memory from a vanished era.

Coverage of the 'post-Beeching' Extension in the ensuing pages is relatively lavish – the firm establishment of diesel-electric traction; the still controversial substitution of DMUs; radio-signalling, Glenfinnan Station Museum... Against the often bleak results of rationalisation can be set the hugely successful revival of summer-season steam (not unmixed with 'heritage' diesel power) and the survival (surely against heavy odds?) of a year-round public service.

Acknowledgements

The return of steam has spread the fame of the Mallaig line. I am grateful to all who have provided photographs new and old (or helped solicit them) and to those who have corrected or enlarged my interpretation. The Mallaig story is sometimes exalted over that of the original West Highland; and 'Extension' suggests that reaching the Atlantic margin was always intended – not in fact the whole truth. It was politic to present the project in these terms, while the West Highland's patron, the North British Company, remained ambivalent, with an eye to Inverness. Assured of state assistance, the North British committed to the Extension; but their doing so was a back-handed admission that the West Highland route to Fort William and Mallaig would prove a dubious investment. It has remained a challenge for the NB's successors. My memories of the Extension 50–60 years ago, from a Fort William perspective, are both fallible and subjective.

JMcG

April 2013

Photos: Alsop Collection; K. Carver; H. C. Casserley; J. Chamney; E. Crawford; J. Currie; M. Fielding; J. Furnevel; A. Gillespie; Glenfinnan Station Museum Trust; J. Gray; Hennigan Collection (courtesy R. W. Lynn); I. Henshaw; A. Johnstone; Lens of Sutton; R. W. Lynn; M. Lyons; M. MacDonald; Mallaig Heritage Centre; A. Mathieson; Christine McGregor; C. J. McGregor; N. McNab; T. Noble; W. Rear Collection; Royal Commission on the Ancient and Historical Monuments of Scotland; D. Spaven; J. D. Stevenson Collection; D. Yuill; also author's collection, or unidentified.

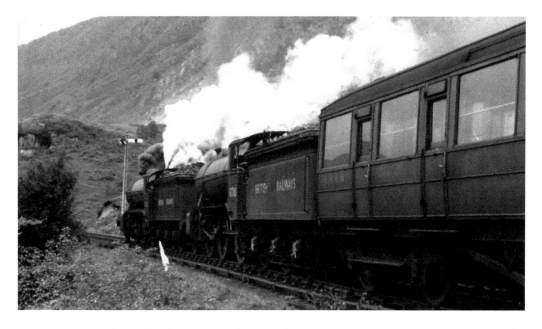

Two K2s restart from Glenfinnan with the morning Glasgow–Mallaig in September 1949; the transition from LNER to British Railways is not yet complete. (*Stevenson*)

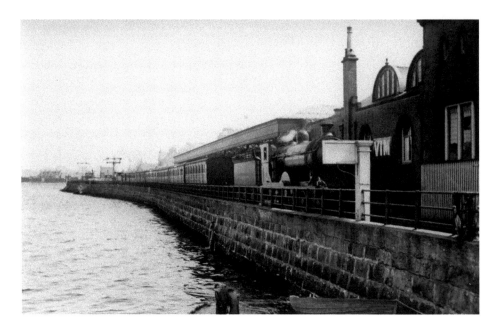

Until 1975 Glasgow–Mallaig and Mallaig–Glasgow trains reversed and changed engines at Fort William's old station. On the Loch Linnhe-side road, arrivals could overshoot the station building, clearing the points at the station throat for remarshalling.

A North British Intermediate, class K (LNER class D32/33), up from Mallaig, is replaced by a Glen. (*Alsop*) Some fifty years later, Type 2 relieves Type 2. (*Furnevel*) Though nameless, the BRCW Sulzers (which became class 27) are remembered, like the Lochs and Glens of steam days, as 'West Highland engines'.

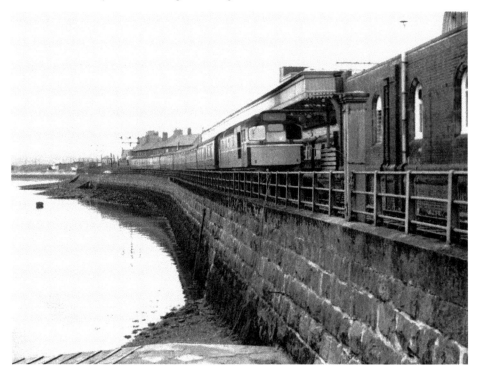

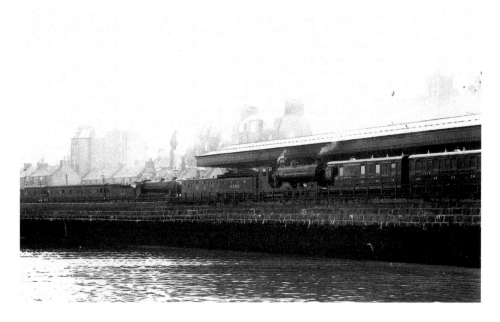

At Fort William in June 1927, 9298 *Glen Shiel* (NBR class K, LNER class D 34), tender-first, takes a Banavie Pier train of rigid-wheelbase stock. K2 4697 shunts on the nearer bay road. The 'imported' 2-6-0 would acquire a name and a modified cab. (*H. C. Casserley*)

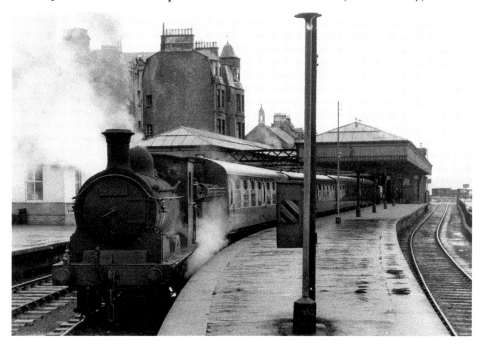

North British 0-6-0s dating from 1888 (rebuilt, they became class C, LNER class J36) were the first goods engines on the West Highland and the local pilots at Fort William. On a wet evening in about 1960, 65313 shunts 'summer extra' coaches; at this date, one set was stabled at the station, another at Mallaig Junction. The overshoot (see p.10) continues across the pierhead.

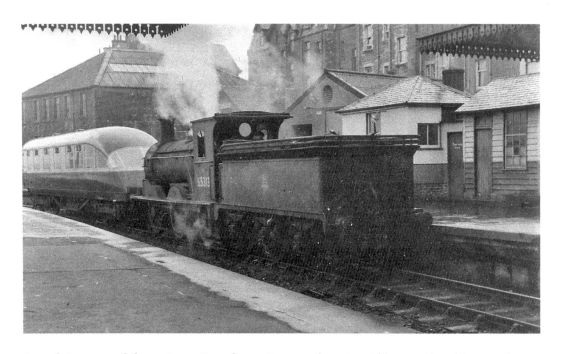

65313 brings one of the ex-Coronation observation cars from turntable to station. (*Stevenson*) Shunting these vehicles, still beaver-tailed for their earliest seasons on the West Highland, added to the pilots' summer duties. The Extension car, based at Fort William, eventually made two return journeys on weekdays.

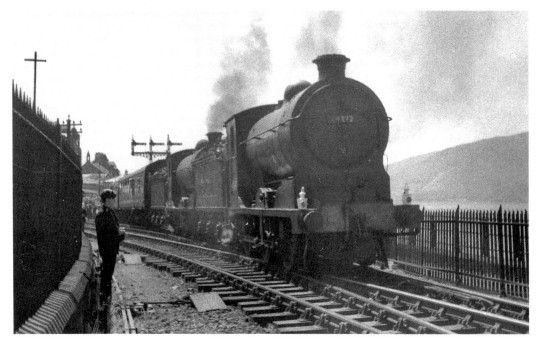

At Fort William in June 1963, J37 (NBR class S) 0-6-0s 64592 and 64636 are ready to take the farewell-to-steam special down the Extension. The heaviest goods engines on the North British, they had always done passenger work when required. (*Currie*)

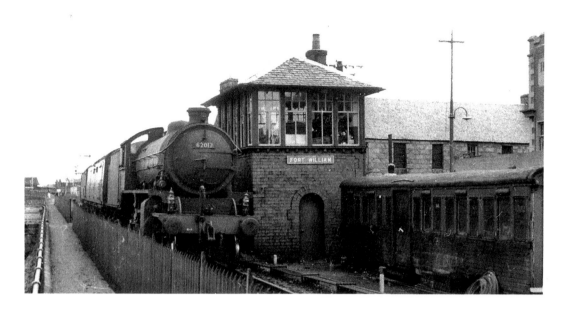

K1 62012 arrives from Mallaig in April 1952. (*H. C. Casserley*) Remarshallings; engines to and from the shed; pilots with empty stock– all required possession of the seawall 'main', commanded by Fort William signalbox. From 1927, the level crossing (for road access to yard and shed at the old fort) was operated from the box. Shunting the town-side goods shed shut off the seawall 'main' and was conducted 'between trains'.

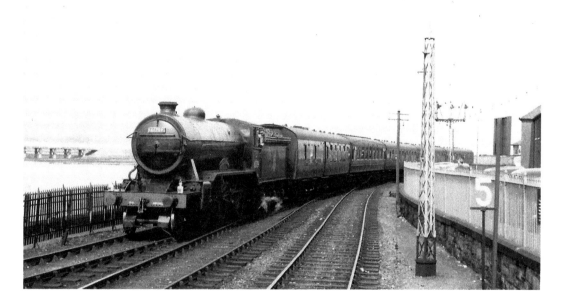

K2 61789 *Loch Laidon* brings the afternoon Mallaig–Glasgow down the seawall in May 1959. (*Stevenson*) Fort William's three platform roads converged abruptly. The British Aluminium Company's pier (now a diving centre) is to the left.

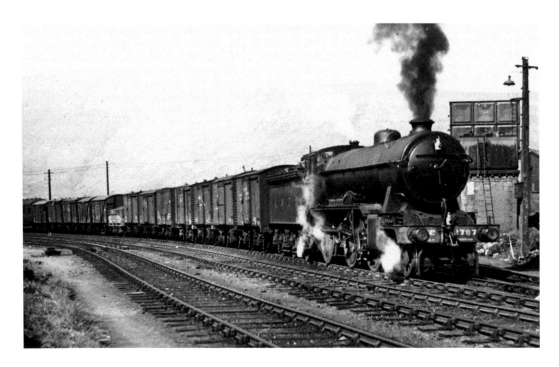

LNER K2 1787 *Loch Quoich* (previously 4697 – see p.11) leaves Fort William yard with the down Extension goods – vans and wagons off the overnight 'Ghost' from Glasgow, plus fish empties. The goods followed the morning Glasgow–Mallaig; at Glenfinnan, the Loch Shiel mail boat waited for both of them. The 'school coach', which made the early up goods from Mallaig a mixed service, went back empty by the down working.

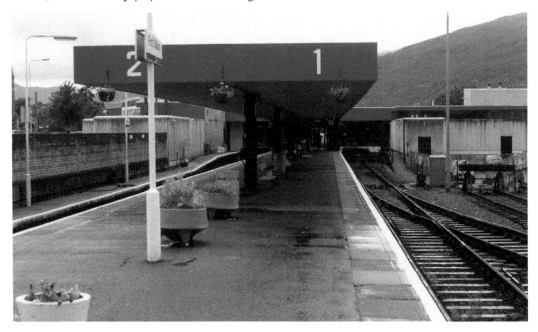

Today's Fort William station, opened in 1975, occupies what was previously the town side of the yard (goods shed, livestock bank, stores and workshops). (*Stevenson*)

The old station has been called 'pompous', with superfluous architectural flourishes. Fort William's new station, seen in 2005, is certainly utilitarian. (*Furnevel*)

By the 1980s EE class 37s had displaced the BRCW 27s. (*C. J. McGregor*) They would be displaced in turn, for passenger work, by DMUs (save on the remodelled 'West Highland Sleeper'). While locomotive haulage lasted, something of the traditional routine continued too, though running round (as against change of engines) became more frequent. Today's Sprinters arrive, reverse and depart with minimum fuss.

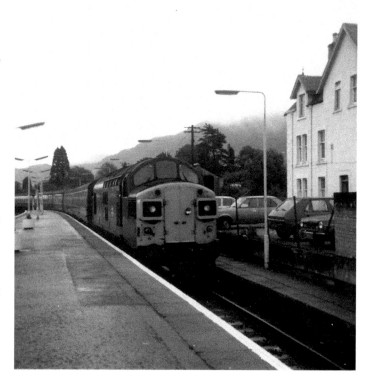

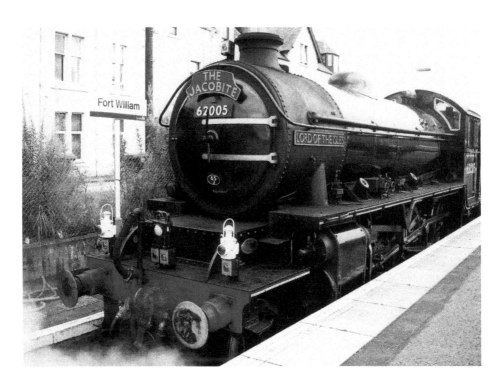

Since the revival of steam on the Extension, the lone preserved K1 2-6-0 has frequently done summer duty. Though named *Lord of the Isles* (recalling a member of the three-cylinder K4 class from which the two-cylinder K1s derived), the engine remains, for purists, just '62005' – ordered under the LNER but delivered to British Railways. (*Johnstone*)

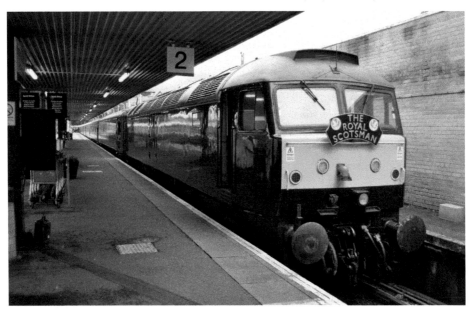

The *Royal Scotsman* luxury tour train has become a regular visitor, with preserved locomotives front and rear, making a return journey along the Extension. In September 2012, 47 237 is seen at Fort William on this duty. (*Henshaw*)

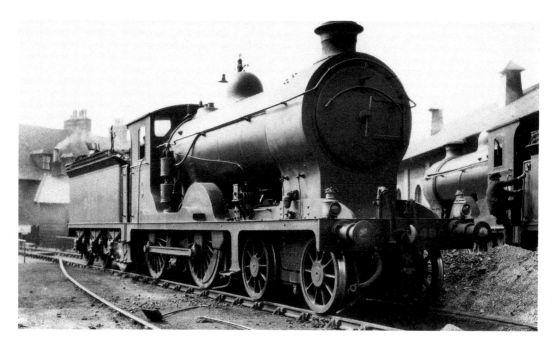

D34 (NBR class K) 9490 *Glen Dessary* and a class-mate, both minus smokebox wing-plates, are on shed at Fort William in the 1920s. (*Lynn*) On the Extension, Glens gradually superseded Intermediates. The LNER would alter the shed layout, provide a modern turntable and demolish the former barracks. (The outer walls and sally port of the old fort, preserved under railway ownership, still survive.)

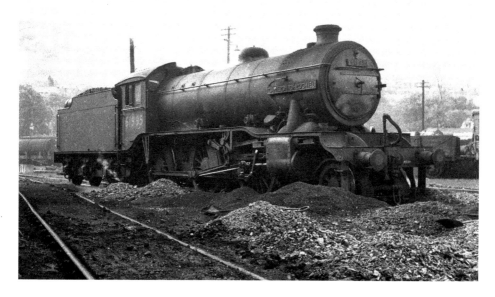

K4 61995 *Cameron of Lochiel* stands on the ash pit at Fort William shed in about 1955. The powerful but temperamental K4s, seen less often on the West Highland proper, continued to take heavy trains on the Extension single-handed.

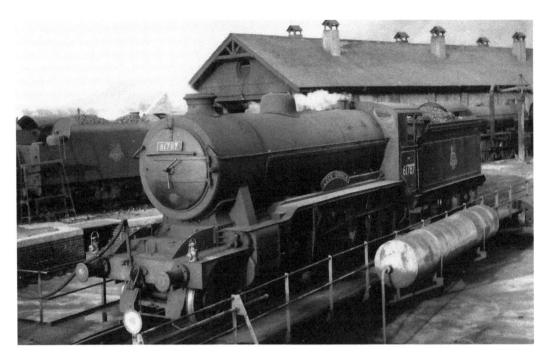

Between Extension duties, *Loch Quoich* (see also p.14 top and p.11 top) stands on the turntable at Fort William. The locomotive array is typical of the mid-1950s. (*Stevenson*)

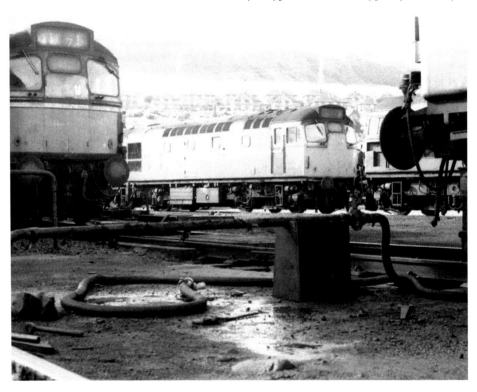

By 1969, BRCW Sulzer Type 2s (class 27) are emphatically in occupation. (*Furnevel*)

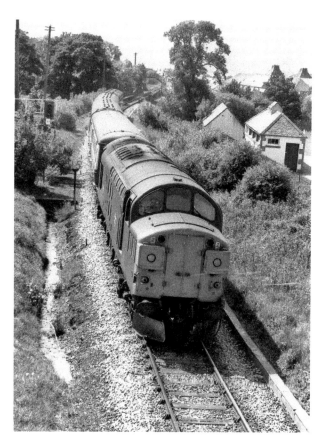

Seen between Nevis viaduct and Mallaig Junction, 37 085 takes a four-coach Mallaig train past Inverlochy school in June 1984. (*MacDonald*) A hint remains of Glenlochy distillery siding (left of second coach). Shunting the siding, besides the passage of scheduled trains, enlivened the school day.

From the 1930s the trailing siding at Mallaig Junction was given over to BP tankers. Transfer was modernised in the 1970s. Beneath the junction signal (recycled boards on an incongruous new post), 66 007 shunts an oil train in March 2011. (*Henshaw*)

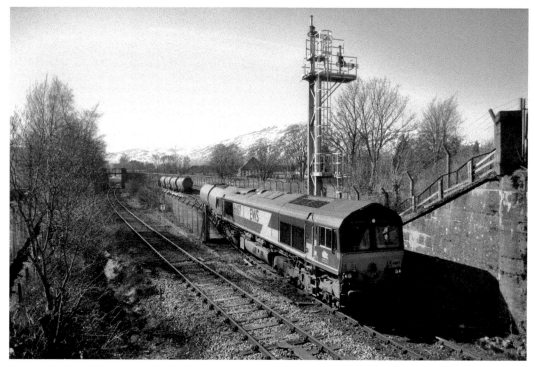

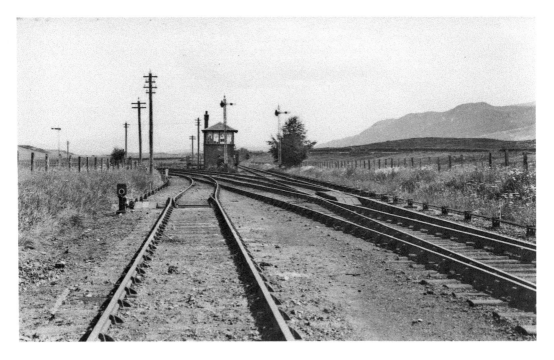

When traffic on the West Highland began, Mallaig Junction (then Banavie Junction) was distinctly 'out of town'. In photographs of the time, signals and signal box stand in an otherwise empty landscape. (*Alsop*)

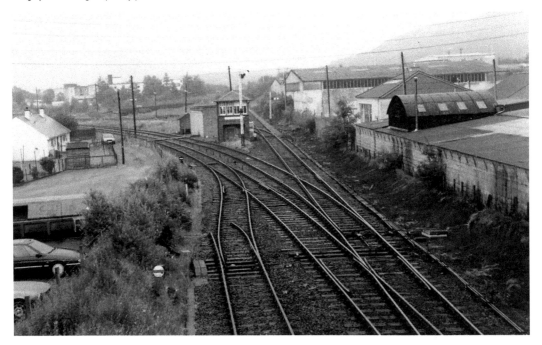

From the 1920s, the area was transformed by construction of the British Aluminium smelter and carbon plant half a mile to the east, with the company village of Inverlochy to the west. Development resumed in the 1960s, and today the Junction is thoroughly enclosed. (*Stevenson*)

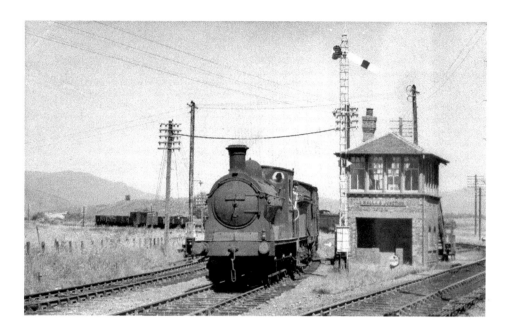

In July 1956 (when building in the vicininity of Mallaig Junction had not yet resumed) the stabling in the angle of Glasgow line and Mallaig line is evident. (*Hennigan/Armstrong*) The old fort yard was always cramped. During the Second World War more sidings were added at the Junction and the original sidings were looped up. Besides J36 65300, there is a K2 shunting in the background.

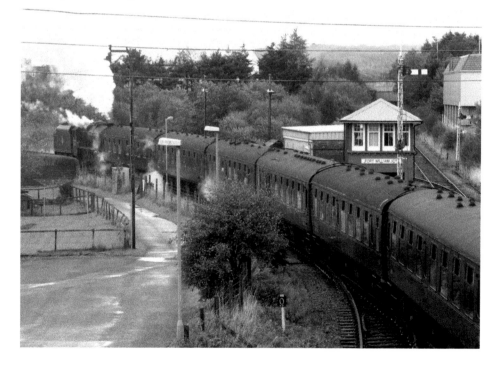

A steam excursion enters the Mallaig road loop in September 2005, hauled by tender-first Black 5 45407 (*Furnevel*) The passing place has always been essential to summer timetabling.

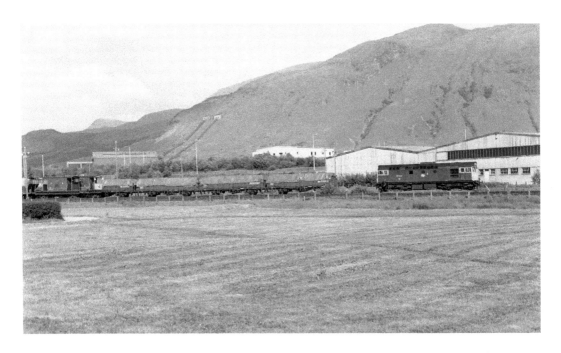

From the early 1970s the Junction sidings, complementing the new depot at Tomnafaire, replaced the town yard. The layout at the old fort, to be occupied in part by the new station, was abandoned to the developers. In June 1981 27 204 runs round a freight from Glasgow Sighthill. The carbon factory is in the middle distance. (*Noble*) Logically enough, 'Mallaig Junction', once 'Banavie Junction', has become 'Fort William'.

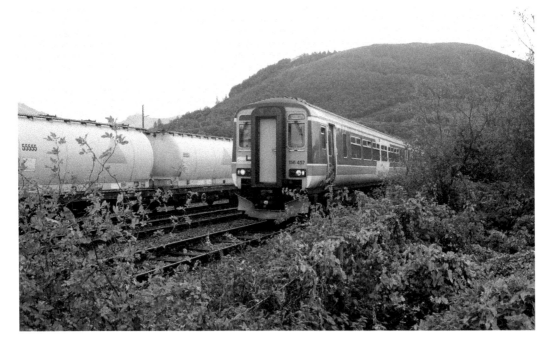

In September 2005 a Mallaig-bound Sprinter comes through the loop, past a rake of alumina tankers. (*Crawford*)

37 404 *Ben Cruachan* is framed in the footbridge at the Mallaig end of the loop in about 1985 (*C. J. McGregor*), while preserved 31 106, with an inspection saloon, approaches the loop in the up direction some twenty years later (*Lyons*). The latter photograph looks north-east to the Great Glen, with Tomnafaire depot out of sight to the right. Here, during construction of the BA complex, the contractor's track crossed on a trestle. The BA's permanent narrow-gauge line, linking smelter and pier, spanned the West Highland on the town-side of the Junction. An abutment of the overbridge appears on p.19.

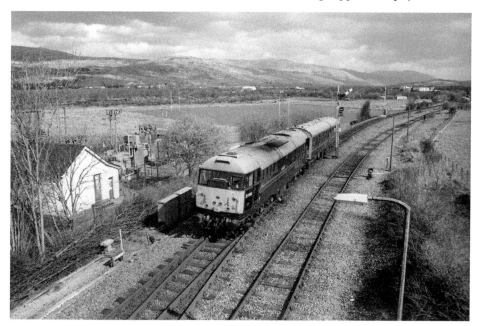

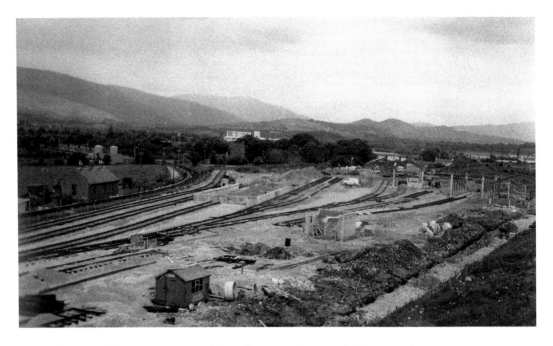

Tomnafaire is under construction in this early 1970s photograph. (*Stevenson*)

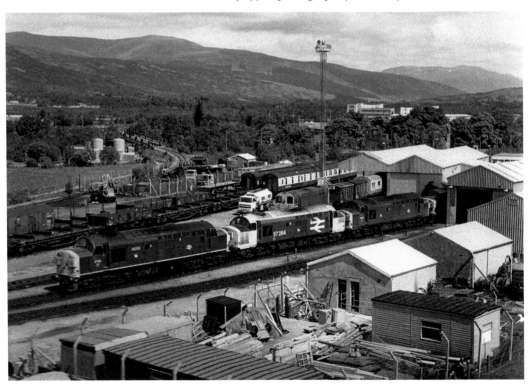

Tom Noble captures the mid-1980s at Tomnafaire (37 033, 081 112 and 264, and 20 089), with Lochy viaduct in the middle distance. 20s were entrusted with 'extras' in the Extension's first diesel summers; one of the class was latterly Fort William's general-purpose spare engine.

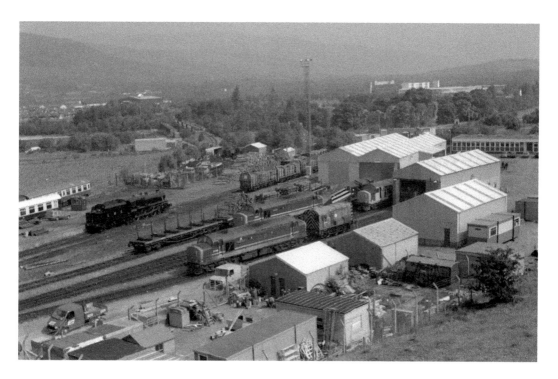

Summer steam, 37s, a class 08 diesel shunter, two independent snow ploughs, timber traffic... Tomnafaire in 1990 still offers variety. (*Crawford*)

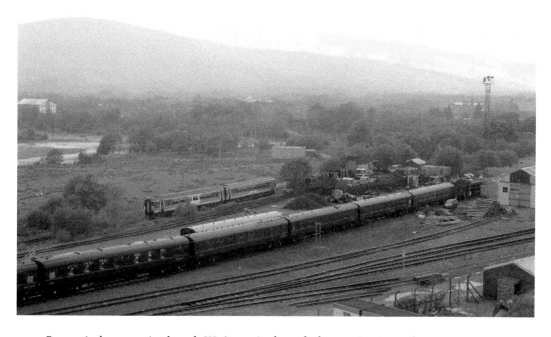

By 2006, the scene is altered. KI 62005 is the only locomotive in evidence as an up Sprinter passes. (*Crawford*)

At Tomnafaire in the mid-1980s are 20 127, with the terrier logo denoting Glasgow Eastfield depot, and K1 (6)2005, in LNER green. (*C. J. McGregor*) The 2-6-0 came into service after Nationalisation, making number and livery unhistorical.

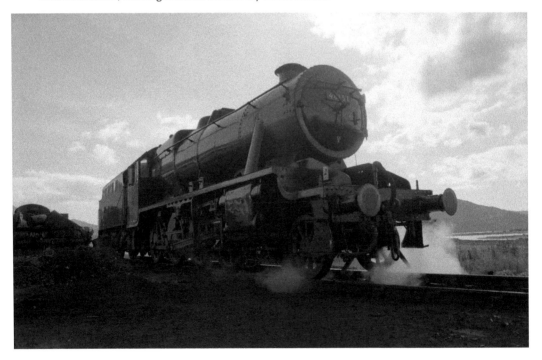

Ex-LMS 8F 2-8-0 48151 is an unusual visitor in June 2012. (*Crawford*)

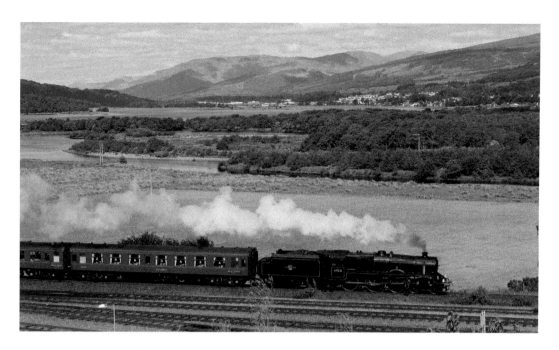

Black 5 45231 *The Sherwood Forester* takes the Jacobite past Tomnafaire in June 2010. (*Fielding*) The route of the Extension, turning westward through Corpach and Annat, can be traced in the background. As approved in 1889 (but amended the following year), the West Highland was to enter Fort William along the River Lochy. The line to Roshven, which Parliament disallowed, would have spanned the Lochy islands (middle-ground), downstream from the present viaduct.

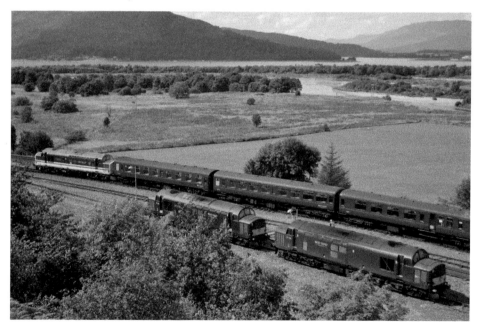

Restored steam apart, Tomnafaire on occasion still plays host to a clutch of 'real engines'... (*Henshaw*)

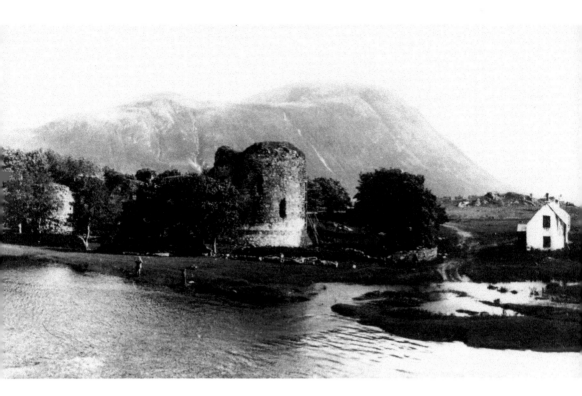

In a pre-railway view of Inverlochy Castle, snow has turned to rain (or vice versa) and the burns on Meall-ant-Suidhe, beneath Ben Nevis, are tumbling white. To the right is rocky Tomnafaire, from which today's railway depot takes its name. (*Gillespie*)

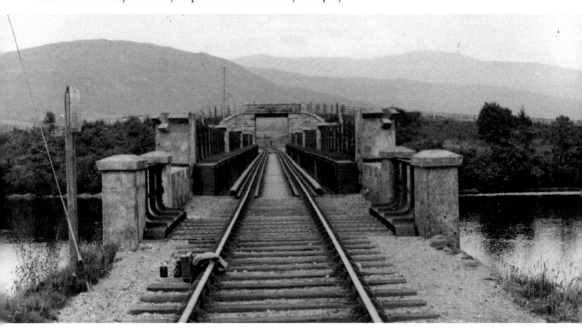

An early photograph captures handsome Lochy viaduct end-on; the girders are partially sunk into the piers, styled to 'match' the adjacent castle ruins. (*Alsop*)

A down
Extension
service of the
1980s crosses
Lochy viaduct
on a day of
low-lying cloud.
(*C. J. McGregor*)

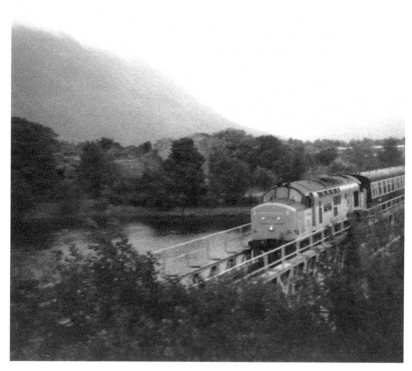

Black 5 5305
*Alderman A.
E. Draper* in
LMS livery
heads a down
steam special,
on a promising
morning in
1990. The
view is to Glen
Nevis. The
Mark 1 rake
in green-and-
cream recalls
the LNER's
1930s excursion
stock.
(*Crawford*)

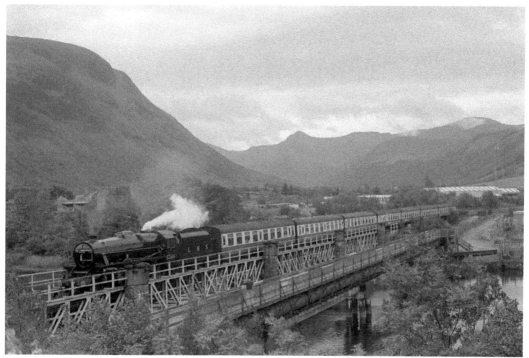

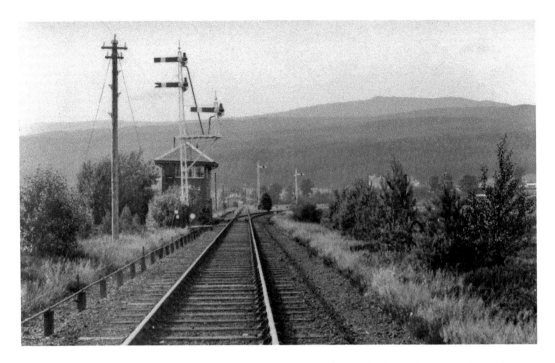

The Mallaig Extension, strictly speaking, begins approximately a mile down the Banavie branch of 1895. In effect the branch was reduced to half-a-mile, curving towards the Caledonian Canal on a rising embankment (today almost obliterated), from the new Banavie Junction. The new Banavie station is straight ahead. (*Alsop*)

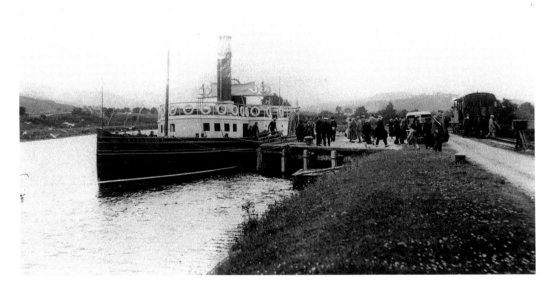

In the final years of passenger traffic on the Canal, tourists disembark from the MacBrayne paddle steamer *Gondolier* for the short walk to Banavie Pier station, situated below Banavie basin. The J36 on boat duty has back-shunted the usual luggage van to the pier-side. (*Stevenson*)

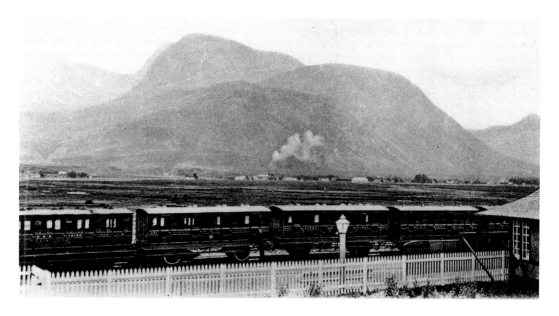

At Banavie in the 1890s (not yet 'Banavie Pier'), 4-wheel stock makes up a 'boat train' (cf. p.11). In the distance is the chimney of Ben Nevis distillery. (*Lens*) Distillery grain shipped on the Canal was tripped from Banavie to Fort William.

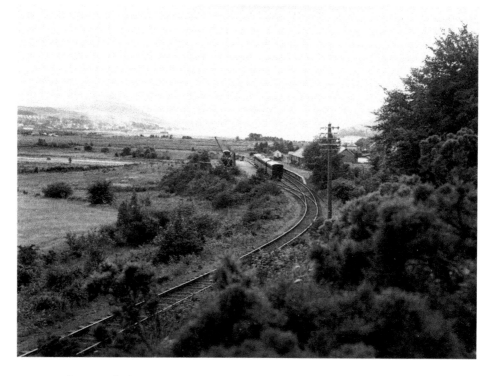

A 1930s photograph shows a rake of elderly coaches stabled at Banavie Pier. The branch had some goods traffic, as the crane testifies. In the distance Fort William is expanding, with new local authority housing on the hillside. The land between the River Lochy and the Canal, today built-up, is as yet undeveloped. (*Rear*)

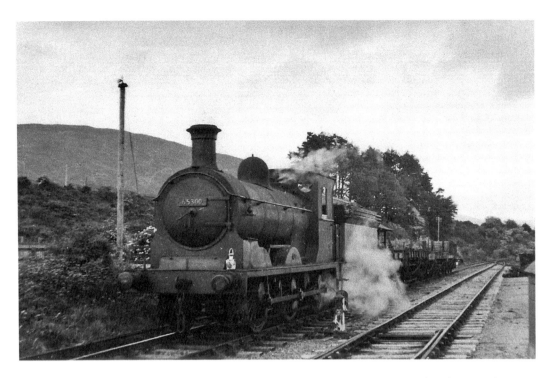

With the branch marked for closure, recovery of permanent-way materials has begun. The engine, as in p.21, is 65300; the date is June 1950. (*Stevenson*)

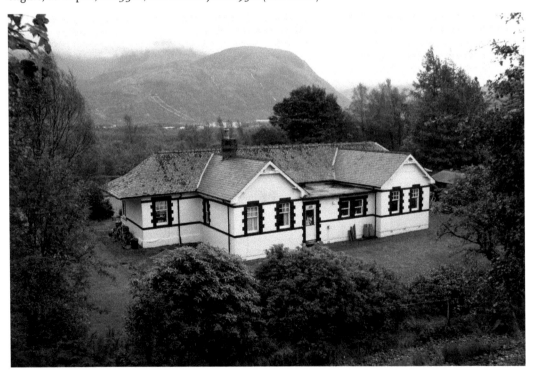

The station building at Banavie Pier has become a modern dwelling. (*Furnevel*)

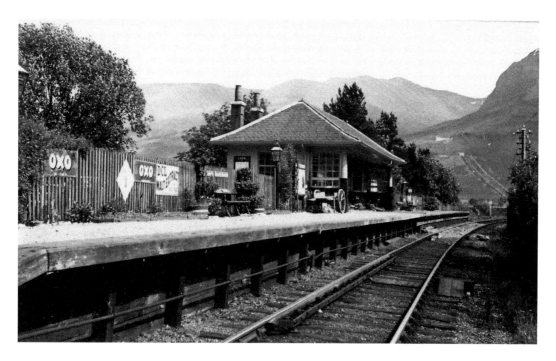

The penstocks on Meall-ant-suidhe, plunging to the BA power-house, are part-completed – fixing this photograph of 'new' Banavie to the mid-1930s. (*Stevenson*)

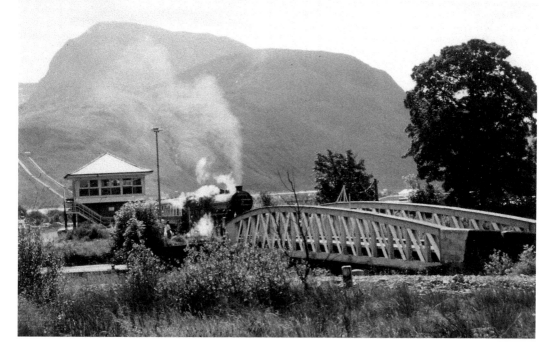

Green K1 (6)2005 departs from Banavie on a Sunday steam special, crossing the swing bridge at the regulation 5 mph. The modern box, radio-signalling centre for the entire West Highland system, had been commissioned not long before. (*Johnstone*)

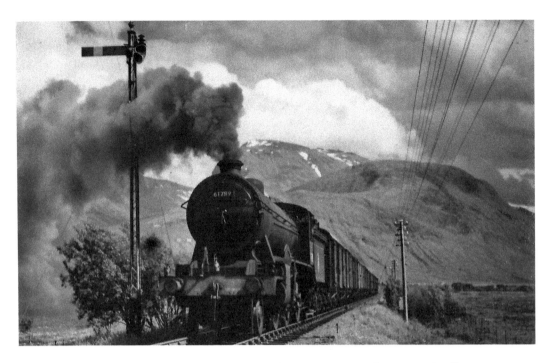

K2 61789 *Loch Laidon* is halted east of Banavie with fish empties in about 1950. (*Yuill*)

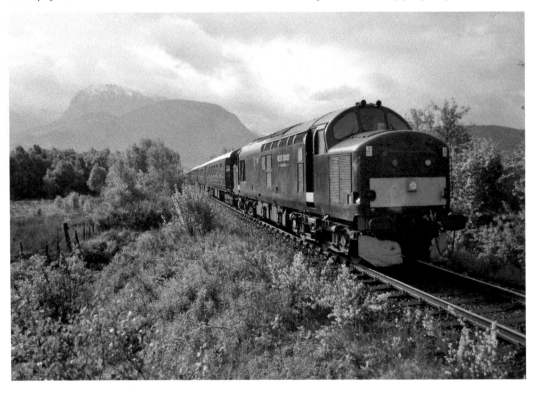

37 685 *Loch Arkaig* approaches Banavie, leading the Royal Scotsman, in May 2011. (*Henshaw*)
Modern naming, though echoing LNER and North British practice, has been inconsistent.

34

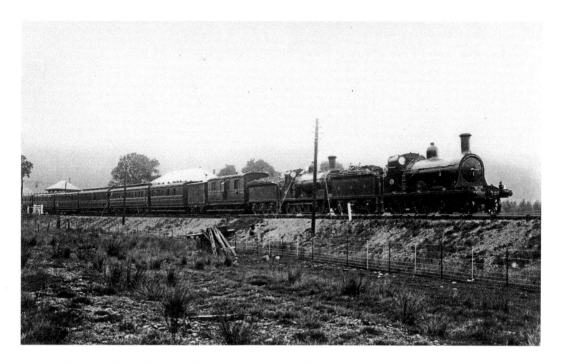

A West Highland Bogie and an 0-6-0 (later rebuilt) head an up train at Banavie. The assisting 0-6-0 is 'inside', North British-fashion. (*Lynn*) The date may be 1901, when the Extension's first summer timetable included Anglo-Scottish through coaches (note the fourth and fifth vehicles) – a brief experiment.

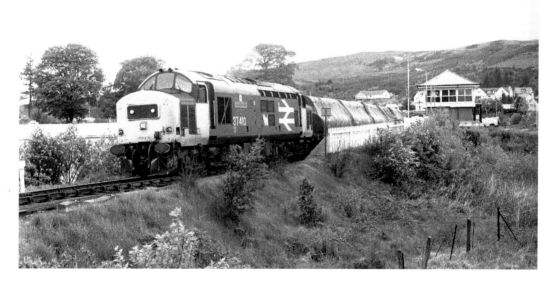

37 410 *Aluminium 100* brings a Corpach–Mossend 'paper' through Banavie in May 1989. The radio-signalling centre ('RETB control') appears clearly. (*Noble*) The train will reverse at 'Fort William' (see p.22).

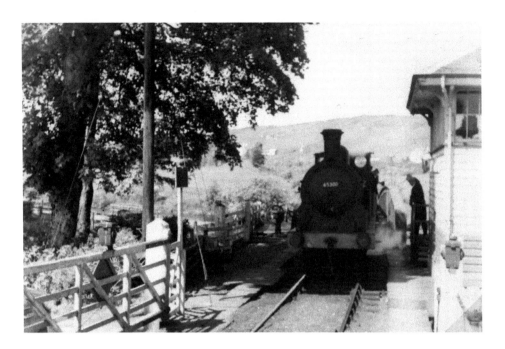

In August 1960, 65300 crosses the Canal in typically deliberate fashion and tablets are exchanged. (*Hennigan/Gee*) A pilot occasionally tripped to Corpach for ballast or livestock. (The auction mart established at Nevis Bridge in the 1890s had been transferred to Annat.) The modern level crossing is east of the station.

When stations both on the West Highland and on the Extension became unstaffed, the Canal crossing still required a presence – one reason for locating the signalling centre there. The swing bridge interlocking is seen in 1930s condition. (*Rear*)

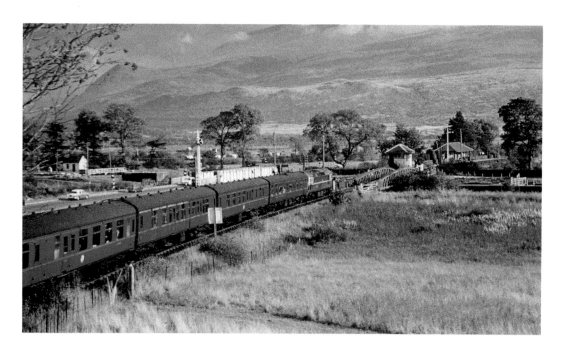

Save for a BRCW Type 2 on the afternoon Mallaig–Glasgow, approaching Banavie, the old order prevails in September 1965 – buffet-restaurant car; lower quadrant signals; original signal box and station building... And the A830 has the narrow canal bridge installed between the Wars. (*Chamney*)

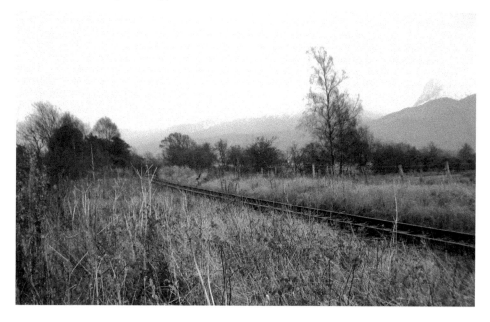

New Banavie Junction–Tomonie, was at first the 'over the Canal' section, with the box at Banavie controlling only the bridge. This unnecessarily elaborate arrangement obtains in p. 35 top. From 1912 Tomonie signal box was eliminated. (Banavie box remained 'Banavie Canal Bridge'.) The Tomonie curve today, with colour light signal, is seen from the west. (*Christine McGregor*)

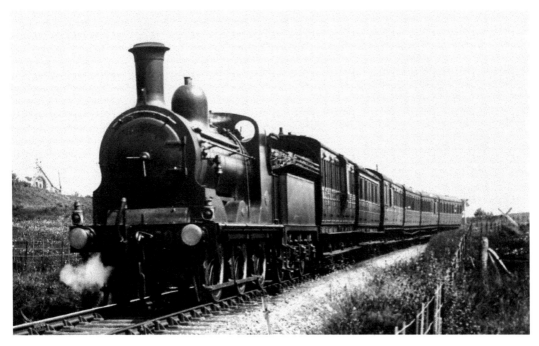

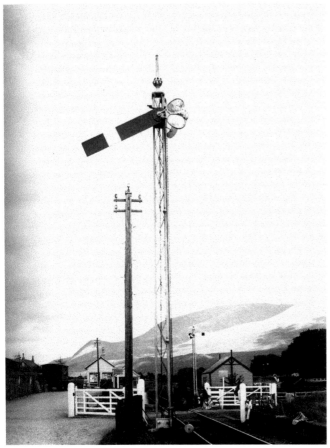

'Unrebuilt' 0-6-0 NBR 706 heads a down train – two six-wheel coaches and four bogies – at Corpach in August 1914 (*Hennigan/ Paterson-Rutherford*). Such duty was not exceptional.

Corpach's 'Extension chalet' station building, destroyed by fire, was replaced by a small wooden structure. The level crossing has its own signals and a tiny cabin. (*Rear*) At first the stations along the Mallaig line were provided with old van bodies, as make-shift stores.

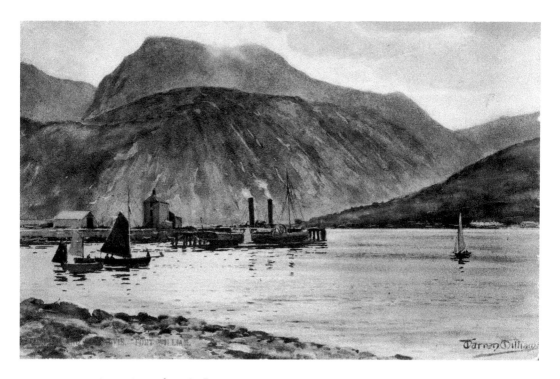

In pre-railway days, the MacBrayne mail steamer plied between Corpach and Oban, calling at Fort William. 'Ben Nevis from Corpach' (here an artist's impression) was already a classic postcard view.

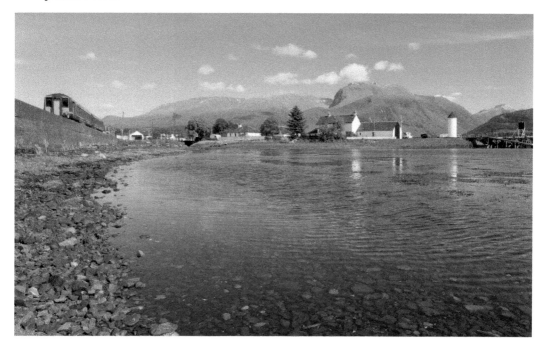

With the mountains sharply defined and Ben Nevis dominant, the midday Glasgow–Mallaig Sprinter leaves Corpach on a fine afternoon in June 2010. (*Fielding*)

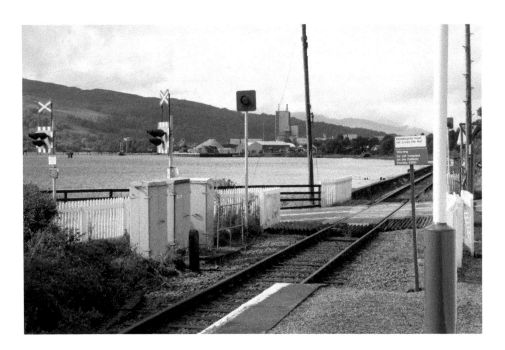

Though the Wiggins-Teape pulp and paper mill established at Annat helped secure the West Highland's 'Beeching reprieve', other factors entered – not least Loch Linnhe's potential as a Cold War base. Corpach level crossing, in the foreground, has acquired modern barriers and signals. (*Furnevel*)

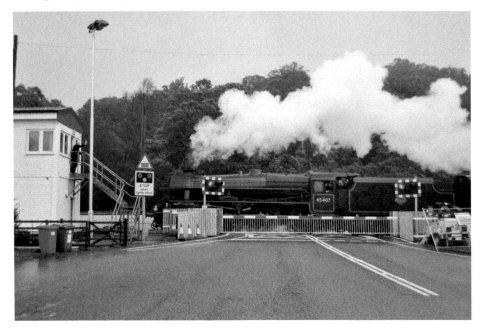

Rail-served Annat mill required a signal box, positioned at the level crossing giving road entry to the plant. Pulp production was short-lived and paper making has ceased too. Though hopes for the site persist, the box has been decommissioned and removed. The crew of Black 5 45407 acknowledge its imminent demise (October 2011). (*Henshaw*)

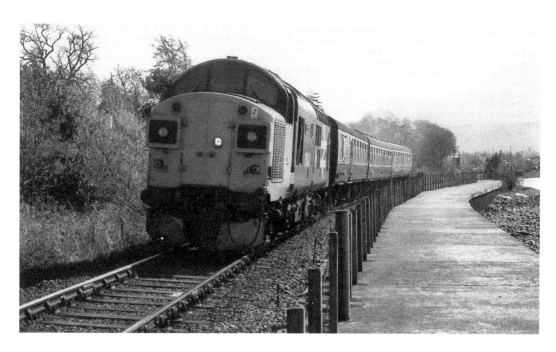

Near Corpach in May 1985, 37 043 *Loch Lomond* heads a three-coach Extension service typical of the period. (*MacDonald*)

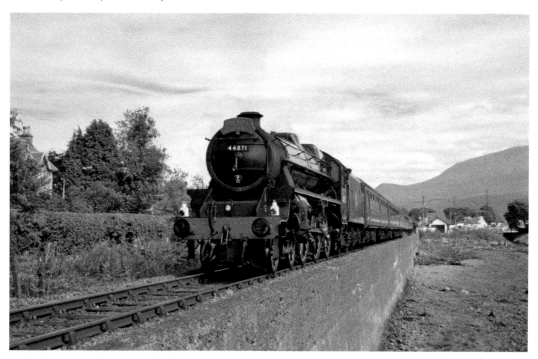

In summer seasons 2011 and 2012 demand justified a second steam working to Mallaig, supplementing the Jacobite. Leaving Fort William in the afternoon and returning mid-evening, it is seen in August 2011, just west of Corpach; Black 5 44871 carries a Royal Highlander headboard. (*Henshaw*)

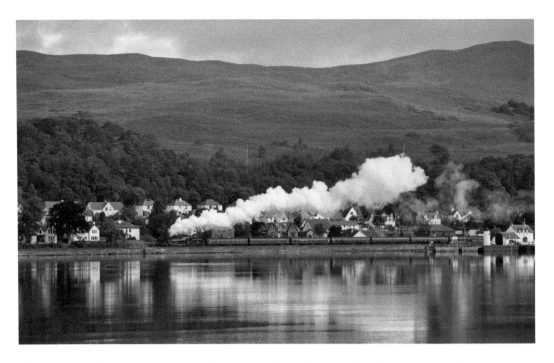

The down Jacobite leaving Corpach is captured from the opposite shore in September 2012. (*Henshaw*)

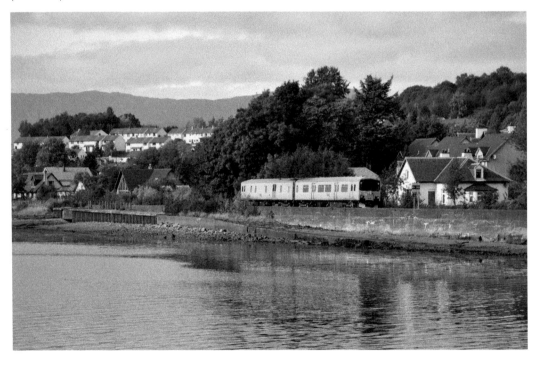

Inspection Unit 2Q08 approaches Corpach from Mallaig in October 2012. (*Henshaw*) A large volume of 'McAlpine concrete' went into retaining walls and protection works between Corpach and Kinlocheil.

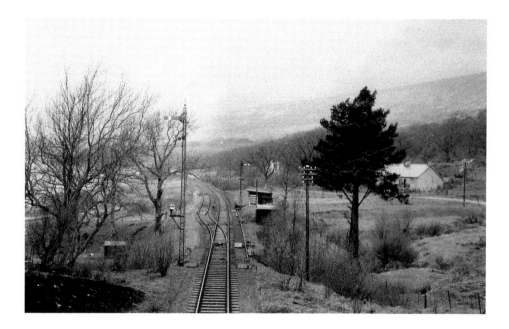

Camus-Na-Ha passing place and siding, where the Annat narrows open into Loch Eil, was installed in 1942. The unbroken single track between Mallaig Junction and Glenfinnan had proved severely limiting when war traffic increased. (*Stevenson*) Camus-Na-Ha's war-time signalwoman unfailingly cycled many miles to duty.

Essentially a refuge for goods trains (passenger services were not crossed), Camus-Na-Ha gave more flexibility to post-1945 Extension timetables. But long-term retention was unlikely, and today the site is overgrown and surrounded by trees. (*Christine McGregor*)

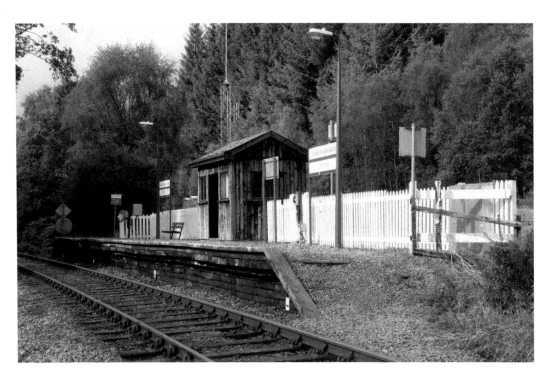

The Outward Bound centre at Achdalieu acquired its own platform in 1985. Loch Eil Outward Bound, seen here in 2005, has been a scheduled halt ever-since. (*Furnevel*)

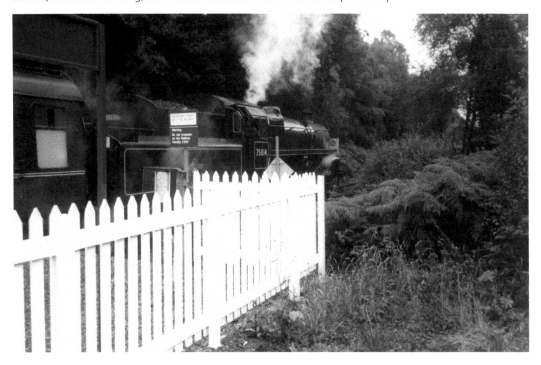

Preserved Standard 4 4-6-0 75014 pauses at the little platform on a Sunday steam special in about 1990.

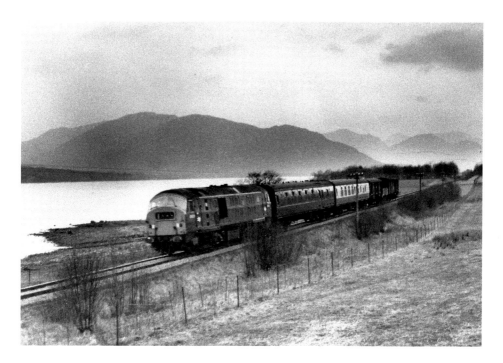

The 'Beeching reprieve' left the Extension's local service in doubt. Traditionally two trains (late afternoon ex-Fort William and early evening ex-Mallaig) had crossed at Arisaig, rotating the West Highland's coach sets. With fish traffic largely gone and little general freight on offer, the year-round locals became an evening mixed working, out and back from Fort William. NBL Type 2 D6103 (class 29) takes the up train along Loch Eil in April 1968. (*Author, courtesy late D. Cross*)

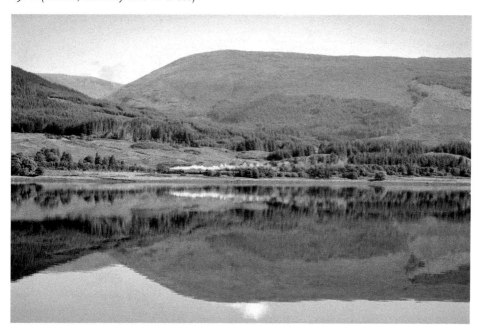

In the right conditions, mirror effects are not infrequent on sheltered Loch Eil. (*Henshaw*)

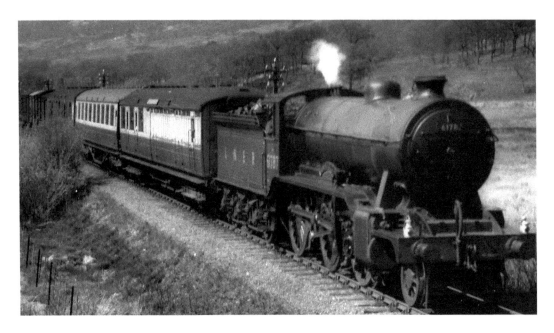

Over the years the Extension has known a variety of mixed services. K2 61787 *Loch Quoich*, with a BR number but an LNER-lettered tender, heads an up example near Locheilside station in about 1950. (*Stevenson*)

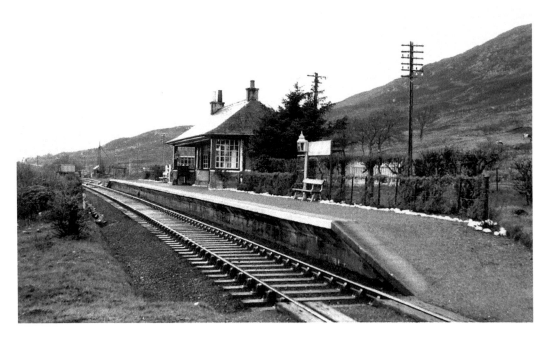

Locheilside – not every train called – might have been named 'Corriebeg' (from a nearby croft). Whether to have a passing place (see also p.43) was a recurring question. (*Stevenson*)

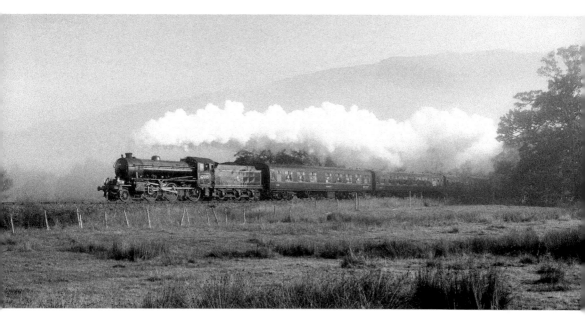

Past Drumsallie, road and railway head inland towards Glenfinnan. For the next mile, K1 62005 (on the Jacobite proper in October 2012) and Black 5 44871 (on the afternoon service some four months earlier) can maintain the brisk pace regularly achieved along Loch Eil. (*Henshaw*) The lower photograph looks back to distant Ben Nevis. In the 1950s Fort William's permanent-way gang took pride in their 'prize length' near Drumsallie.

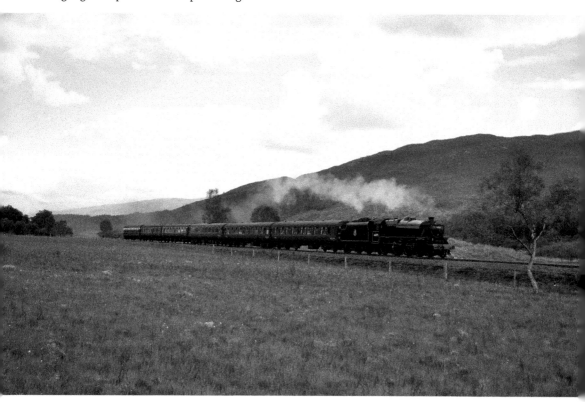

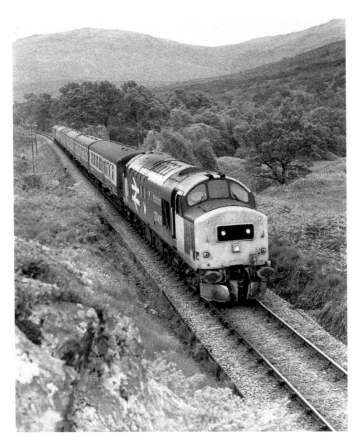

The gradient steepens abruptly, behind Craigag and through the first (and shortest) of the Extension's eleven tunnels, before easing for Glenfinnan viaduct. In June 1986 37 405 *Strathclyde Region* heads the morning Glasgow–Mallaig. (*Noble*)

In May 2012 57 001 makes the descent with the Queen of Scots stock. The train has just left the viaduct. (*Henshaw*)

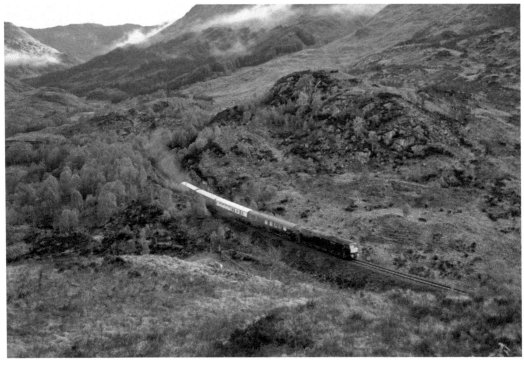

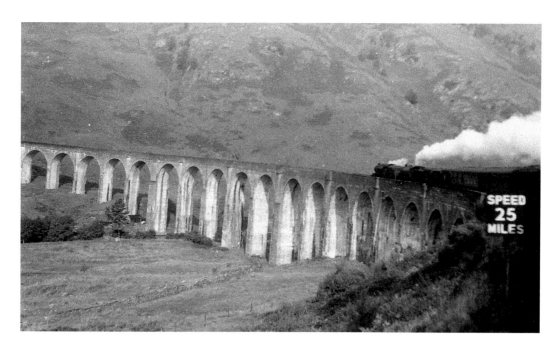

A K1 (as train engine, leading) and a K2 (as pilot, 'inside') take the morning Glasgow–Mallaig over Glenfinnan viaduct in the early 1950s.

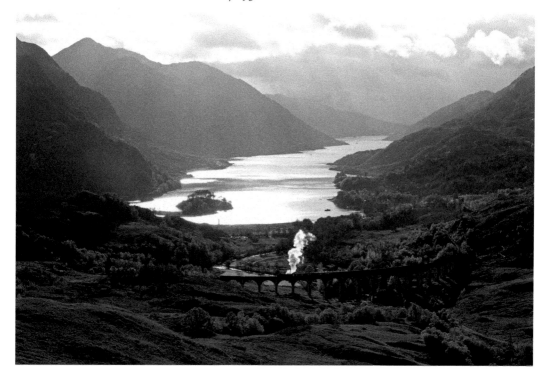

K1 62005 returns tender-first to Fort William with the last up Jacobite of 2012. Glenfinnan station is hidden round the curve to the right. (*Fielding*) A station site east of the viaduct, more convenient for Loch Shiel pier, was considered but not pursued.

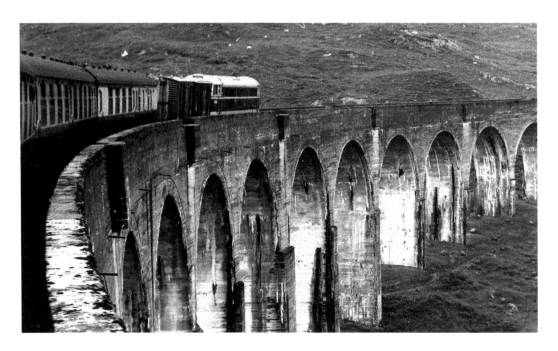

Brush Type 2s were among the diesel-electric locomotives tried on the West Highland. D5511 heads the afternoon Mallaig–Glasgow. (*Stevenson*) Fish vans going south and empty vans returning north (see also p.49) were often attached to passenger trains.

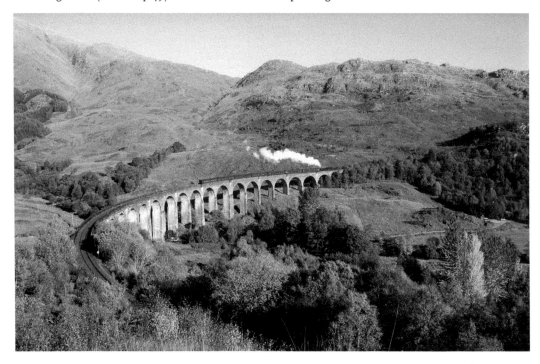

A Black 5 takes the up Jacobite tender-first. (*Gray*) The reconditioned turntable added to the Junction sidings at Fort William, in the 'V' of Glasgow road and Mallaig road, allows variation (tender-first down and chimney first up); more even tyre wear is a practical benefit.

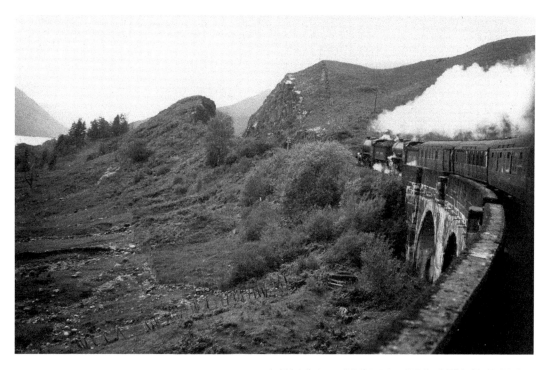

K2s 61784 and 61785 (both nameless) attack the gradient east of the viaduct. The scene is post-Nationalisation but essentially LNER. (*Stevenson*)

Ewan Crawford captures 5305; the engine is in LMS guise, the coaches in 'mock LNER', and the year is 1990 (see also p.29).

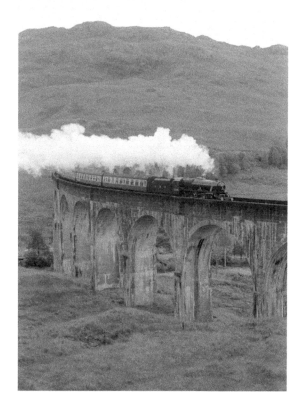

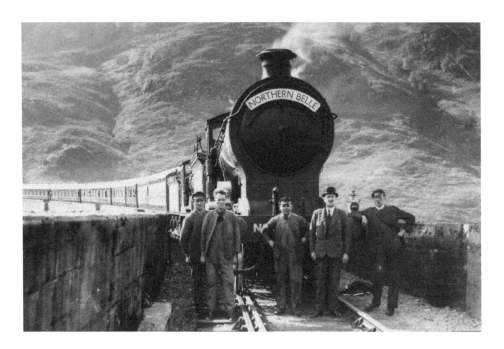

Returning from Mallaig in June 1934, the Northern Belle (day coaches) pauses on Glenfinnan viaduct for the view down Loch Shiel (see p.49), a practice which the Jacobite has resumed. On the West Highland, both day portion and night portion were allocated a pair of Glens. The engine crews and an accompanying inspector pose with the leading engine, 9221 *Glen Orchy*; its partner is 9298 *Glen Shiel*. (*Hennigan/Turner*)

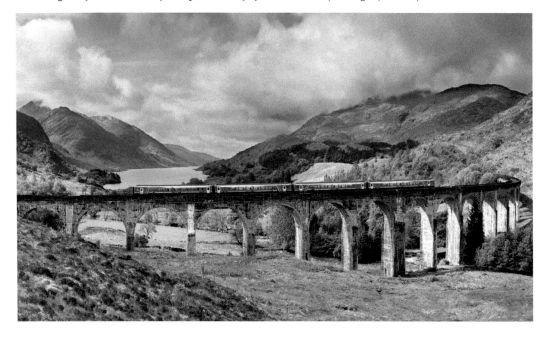

In the winter timetable (October–June), DMU Sprinters now cross the viaduct eight times daily. Whatever their limitations, four services in each direction between Fort William and Mallaig betters the traditional ration. (*McNab*)

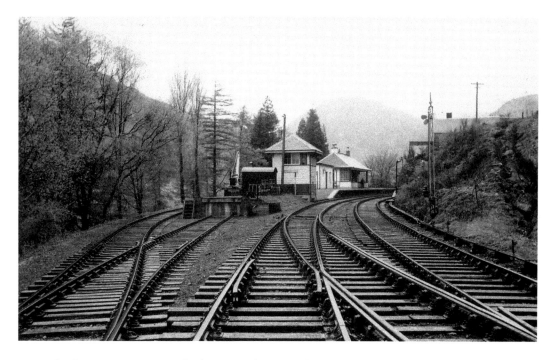

Glenfinnan station is seen looking west (*Stevenson*). Extension signal boxes were supplied 'off the peg' by the Railway Signal Company.

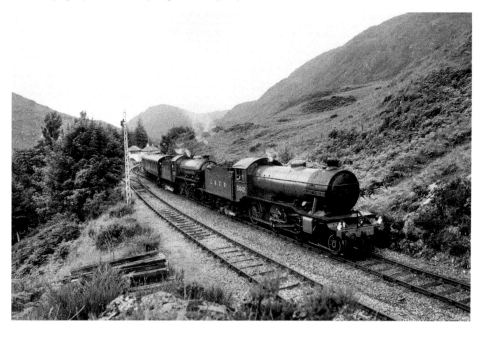

In 1994 the West Highland centenary celebrations brought together K4 3442 *The Great Marquess* and K1 (6)2005, both in LNER green, seen leaving Glenfinnan for Fort William. (*Gray*) As a (not invariable) rule, the K4s had worked alone, but in preservation the *Marquess* has been variously paired. With radio-signalling well-proven, semaphores have been removed. A few lattice posts still stand today.

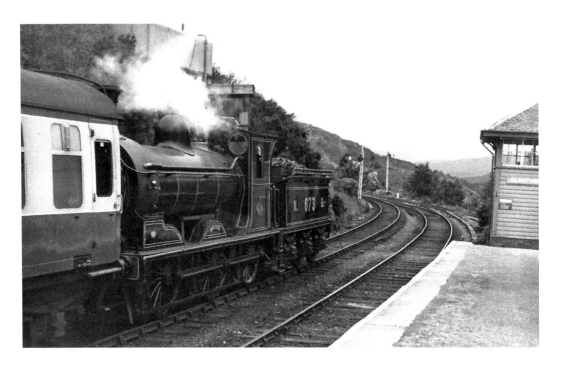

In 1984 the Scottish Railway Preservation Society's J36 made a summer visit to Fort William, in NBR condition as 673. (*Yuill*) *Maude* is seen returning tender-first from Glenfinnan. The naming of twenty-five NB class C 0-6-0s followed their time in France during the First World War. (Lieutenant-General Sir Stanley Maude served on the Western Front, at Gallipoli and in Mesopotamia.)

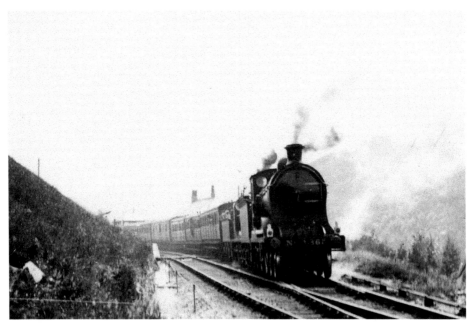

North British Intermediate 865 and 'unrebuilt' 0-6-0 679, on a down passenger, stand at Glenfinnan in July 1914. (*Hennigan/Sherlock or Patterson-Rutherford*)

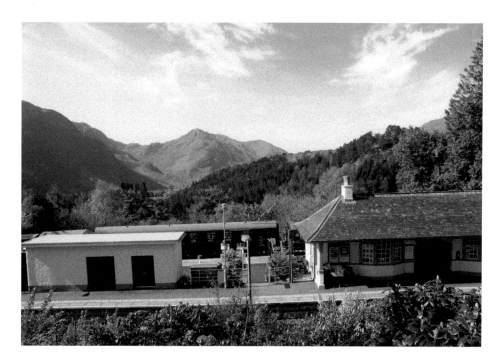

In 1991, Glenfinnan station building became a museum devoted to the history of the Extension. An open Mark 1 coach provides the associated café, while a compartment vehicle has been converted to a bunk house. The station store (foreground), which replaced the original van-body, held items for transfer to and from the Loch Shiel vessel. (*Glenfinnan Station Museum Trust*)

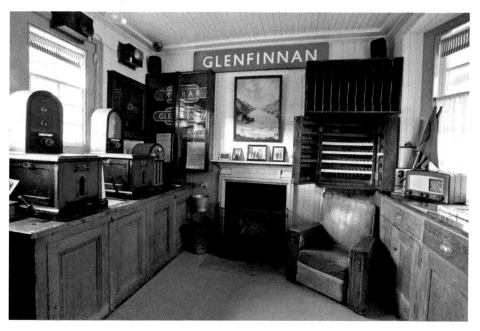

The Museum has recently been refurbished and the interior displays reorganised. (*Glenfinnan Station Museum Trust*)

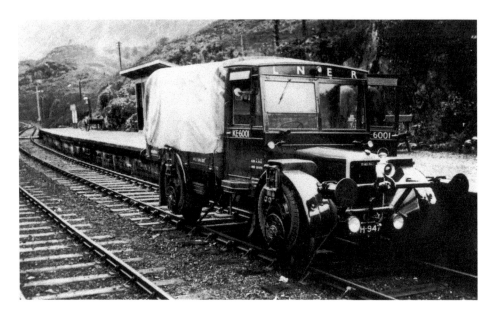

The LNER introduced an experimental road-rail vehicle on the West Highland, anticipating by many years the modern methods of Network Rail. The Karrier 'ro-railer' is seen at Glenfinnan in 1936. (*Stevenson*)

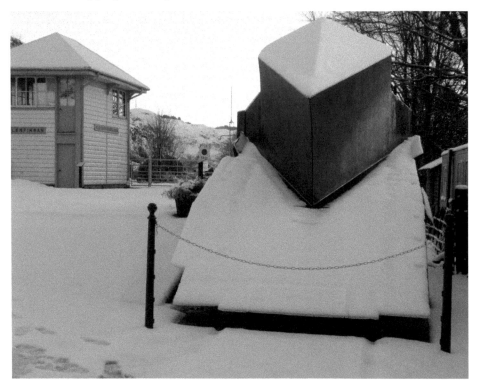

The Museum's snow plough is found in appropriate conditions. The signal box, refurbished like the station building, has enlarged the Museum's display and storage space. (*Glenfinnan Station Museum Trust*)

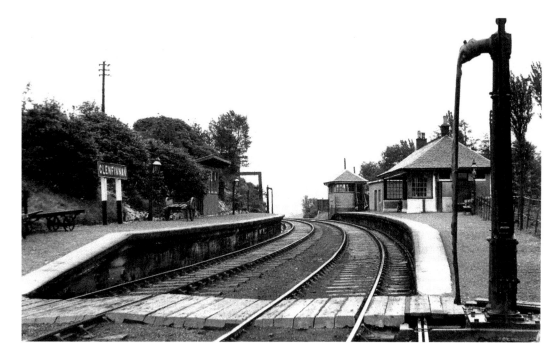

The Glenfinnan water columns are prominent in this east-looking view. (*Stevenson*) That the water tank (see also p.54) could be brought back into use contributed mightily to steam's restoration. Passing stations on the Extension – Lochailort and Arisaig besides Glenfinnan – were given wooden waiting rooms on the up side.

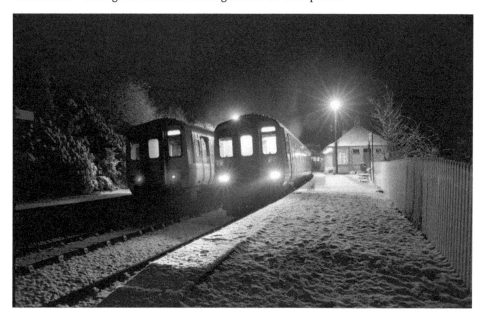

Sprinters meet in darkness. (*Crawford*) The midday Glasgow–Mallaig has been scheduled over several years to cross the evening Mallaig–Glasgow at Glenfinnan. The pre-DMU winter timetable gave no service ex-Glasgow between 6 a.m. and late afternoon and no Mallaig departure for Glasgow after early afternoon.

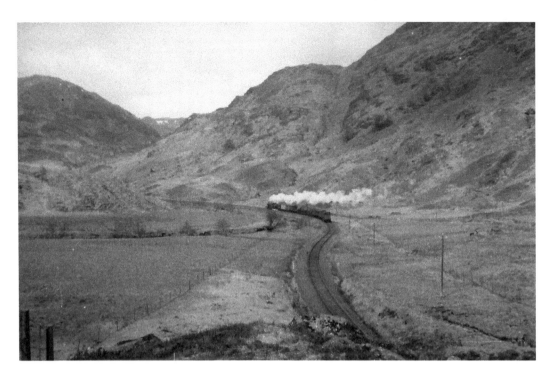

A down goods climbs out of Glenfinnan in the 1950s, following the Shlatach burn. The narrow, unimproved A830 can just be discerned on the right. (*Yuill*)

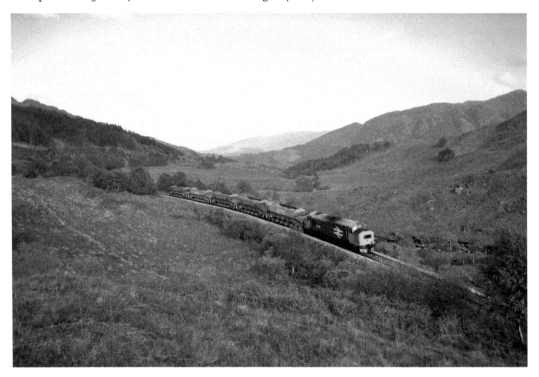

37 425 makes the same ascent with a ballast train some fifty years later. (*Henshaw*)

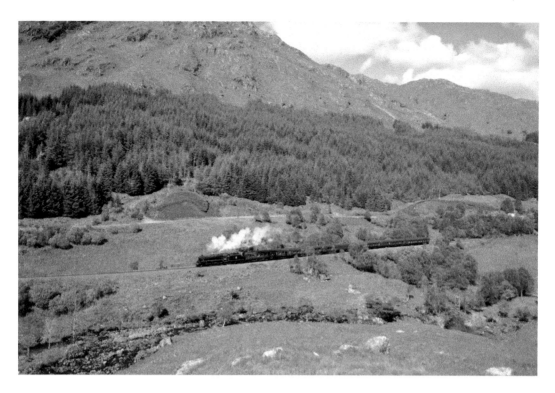

Black 5 44871 is seen west of Glenfinnan with the down supplementary Jacobite in June 2012. (*Henshaw*)

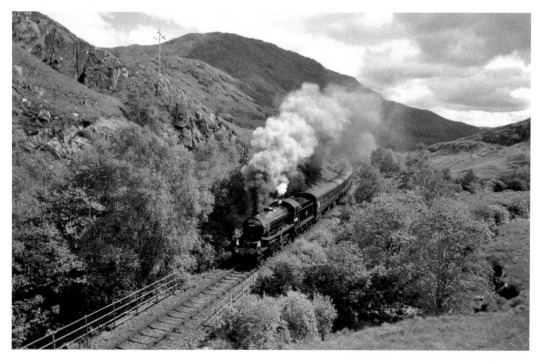

K1 62005 nears the summit of the Extension in June 2012. (*Henshaw*)

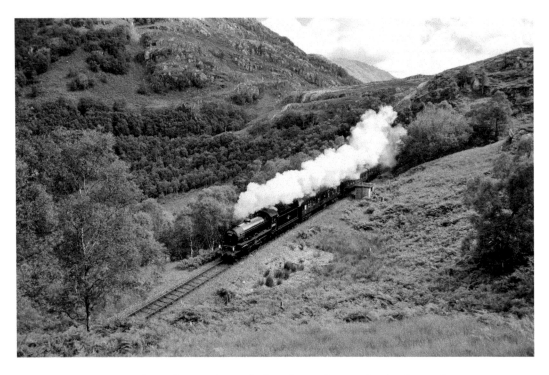

From the summit bores above the Vuie burn, the line descends to Loch Eilt. The Jacobite appears between the two tunnels in July 2012. (*Henshaw*)

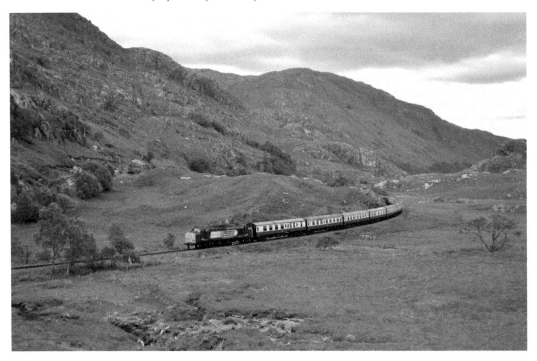

There are 37s front and rear on a Dumbarton–Mallaig special in June 2012. 37 688 leads. The Mark 1 stock in mock carmine-and-cream is reminiscent of the early BR period. (*Henshaw*)

A Sprinter passes Essan, on the southern shore of Loch Eilt – once a patch of arable and pasture for gamekeeper and shepherd in the midst of deer country. (*Gray*) The landowner, anxious for his sport, wanted the line diverted across the narrows but settled for a 'shooting platform' at Lechavuie.

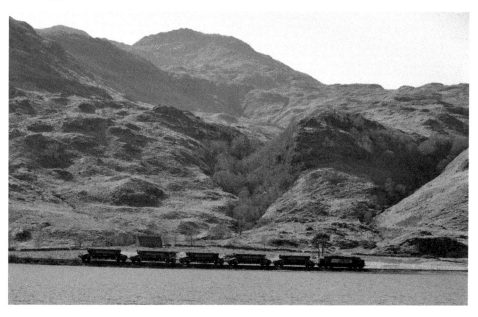

In March 2012 37 688 takes a ballast train past Essan, where the cottage is now a walker's bothy. (*Henshaw*)

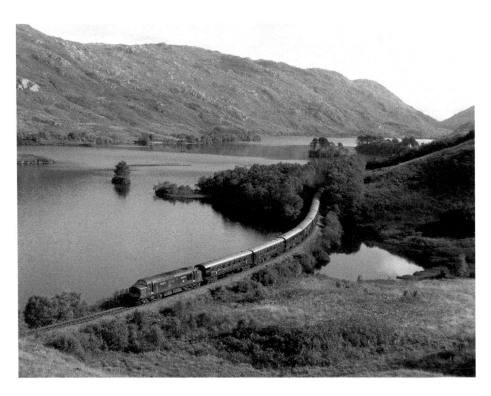

The Royal Scotsman, returning to Fort William, crosses the causeway at the western end of Loch Eilt. 37 676 *Loch Rannoch* is at the rear. (*Henshaw*)

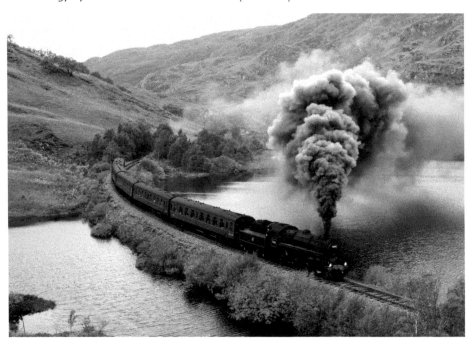

Standard 4 2-6-0 76001 takes the up Jacobite over the causeway. (*Mathieson*) The class did summer duty on the Extension in the 1950s, making this engine an authentic visitor.

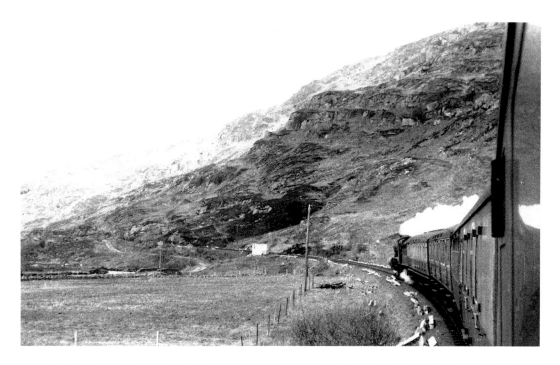

In April 1952 the morning Glasgow–Mallaig enters the short valley of the River Ailort, which drains Loch Eilt seawards. (*H. C. Casserley*) The A830, today improved beyond recognition, is to the left. Beginning as Thomas Telford's early nineteenth century 'Lochnagaul Road' to Arisaig, it long remained over many miles much as Telford had left it.

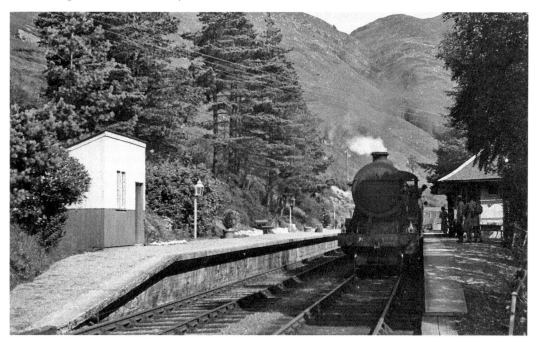

Loch Laidon (see also p.34) brings a down passenger into Lochailort. The fireman is ready to exchange tablets. The up side waiting room was tiny.

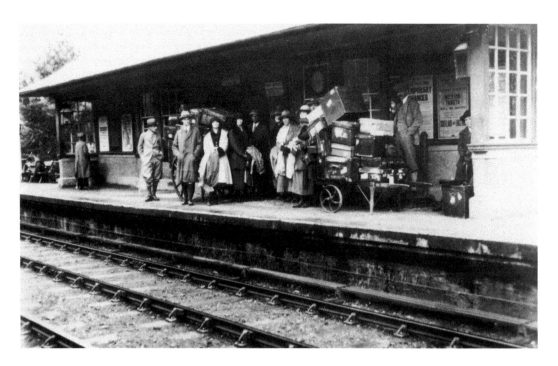

Visitors to Inverailort House pose at Lochailort. The posters are North British, suggesting a date about 1920, if not pre-1914. The sign left of the clock is a reminder that several West Highland and Extension stations had post office facilities. The stationmasters doubled as sub-postmasters. (*RCAHMS/Thornber*)

A down mixed train stands at Lochailort in the late 1960s. The crew are 'in period'. (*Frank Spaven Collection, courtesy D. Spaven*)

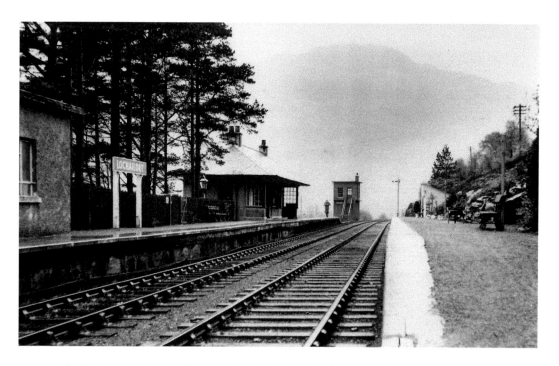

Lochailort's original signalbox perched on the embankment at the west end of the loop; the LNER replacement was plain and stark. (*Stevenson*)

Iain Henshaw looks west from the footplate of 62005 at today's minimal station. Besides the Junction loop (see p.21), Glenfinnan and Arisaig remain as passing places between Fort William and Mallaig.

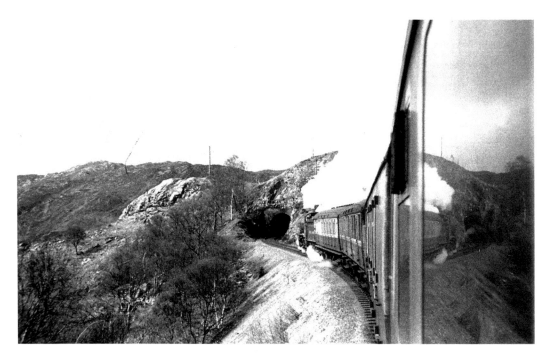

From Lochailort K2 61782 *Loch Eil* climbs westward with the morning Glasgow–Mallaig (see also p.63). Eight of the Extension's eleven tunnels are between Lochailort and Arisaig. By the early 1950s, West Highland coach sets combined ex-LNER vehicles (in the main Gresley, a few Thompson) with BR Mark 1s. (*H. C. Casserley*)

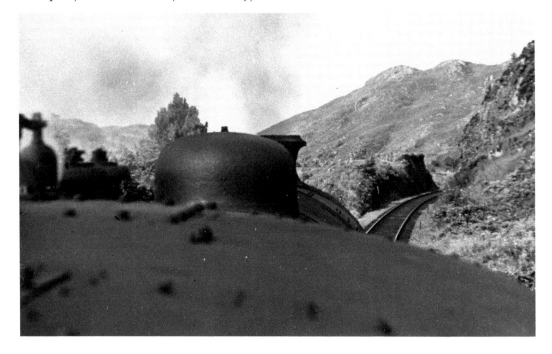

Rock cuttings now abound. Excavation during construction yielded only a limited amount of soft spoil; several embankments were fashioned out of rock debris, and built rather than tipped.

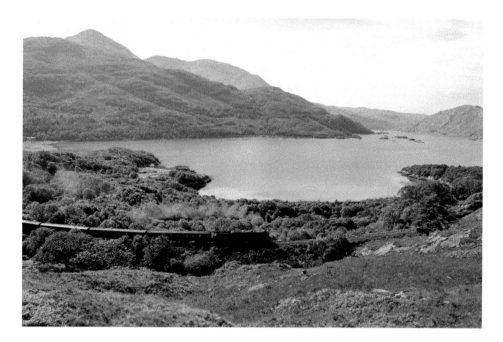

Above Camus Dreisach, the view is down Loch Ailort towards Roshven, where the 'Extension' of 1889 would have terminated. Roshven's suitability as a harbour was debatable. During construction of the Mallaig line, sea-served Camus Dreisach was a base for engineer and contractor. (*Gray*) The modern road to Kinlochmoidart and Acharacle via Inverailort made the Loch Shiel mail boat expendable.

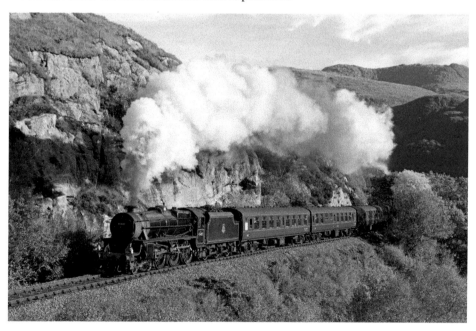

Black 5 45407 (disguised as 45487 for waiting photographers) follows the curves above Loch Ailort in October 2010. The line is about to turn inland across the Polnish peninsula. (*Fielding*)

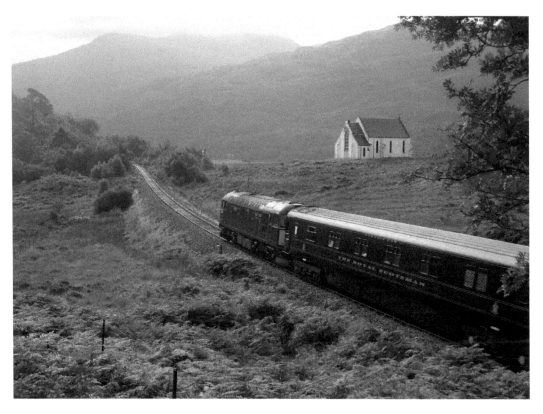

Immediate views and wider prospects alternate on the brief up-and-over to Loch-nan-Uamh, but Polnish church is a prominent landmark. Preserved 'narrow' class 33 207 *Jim Martin* heads the Royal Scotsman downhill towards the Lochailort tunnels. (*Carver*) On the western descent, a down Sprinter passes the Black Water (Loch Dubh) in July 2011. (*McNab*)

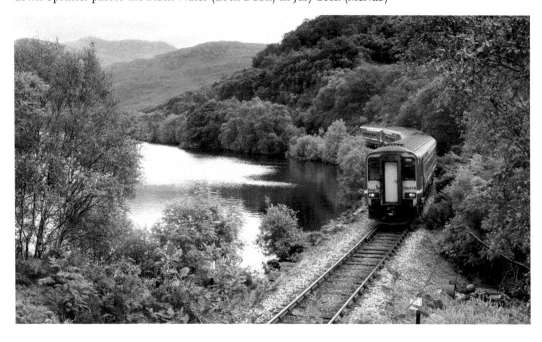

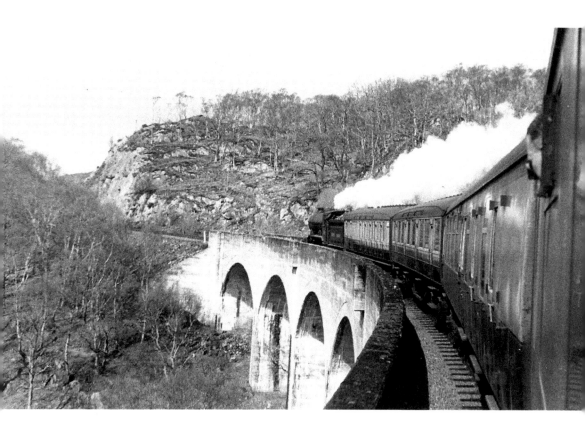

Loch Eil crosses Polnish (Arnibol) viaduct (see also p.63 and p.66). (*H. C. Casserley*)

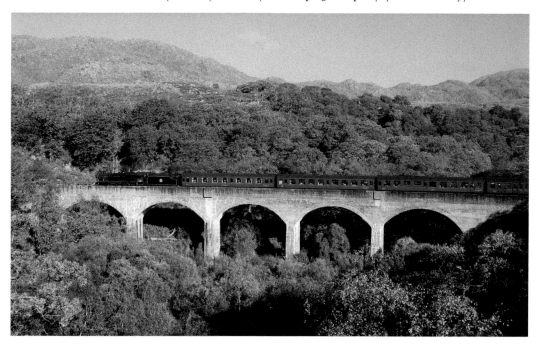

Black 5 44871 crosses with the down Jacobite in October 2010. (*Gray*)

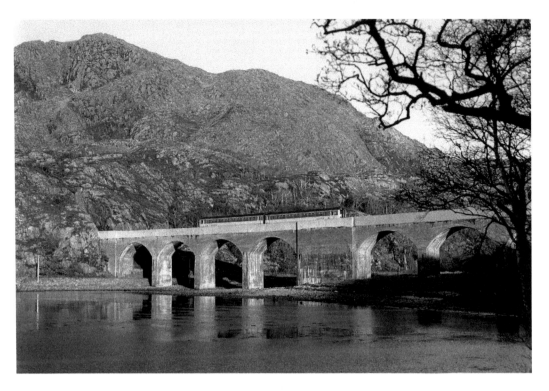

Tom Noble captures a Sprinter on Loch-nan-Uamh viaduct early in the DMU era.

Tunnel follows tunnel ... Through one short bore, the next can be seen. (*Stevenson*) A horse killed during construction was said to be entombed in one of the piers of Glenfinnan viaduct. Investigation with modern technology has transferred the story to the squat structure at Loch-nan-Uamh.

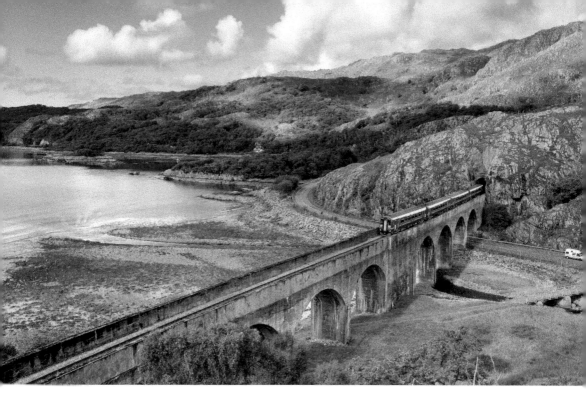

In another view of Loch-nan-Uamh viaduct the route ahead appears, climbing by Cuildarrach into Glen Beasdale. It is September 2008 and Sprinters are long-established. (*McNab*)

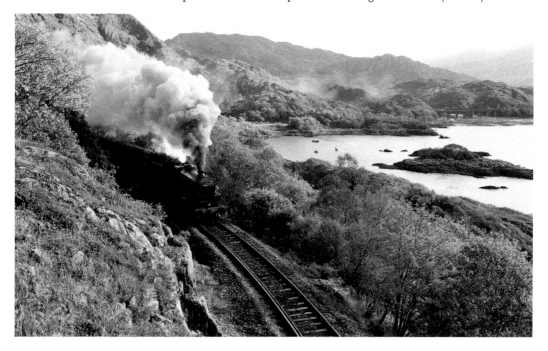

In a corresponding photograph, looking back to the viaduct, the smoke of Black 5 44871 lingers above the tunnel portals. (*Gray*)

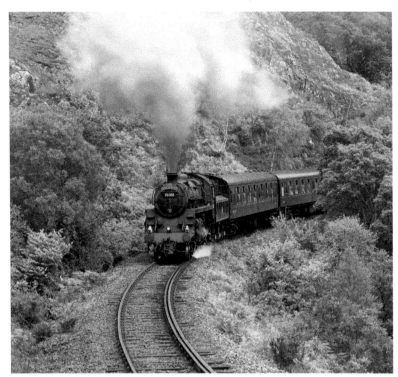

Standard 4 76001 climbs past Cuildarrach in September 2008 with the down Jacobite. (*McNab*)

Swinging inland once more, K1 62005 gets to grips with Beasdale bank in October 2012. (*Fielding*) The seven-coach Jacobite makes a respectable load – though the K4s were known to take nine. (See also p.49, which shows the returning train later the same day.)

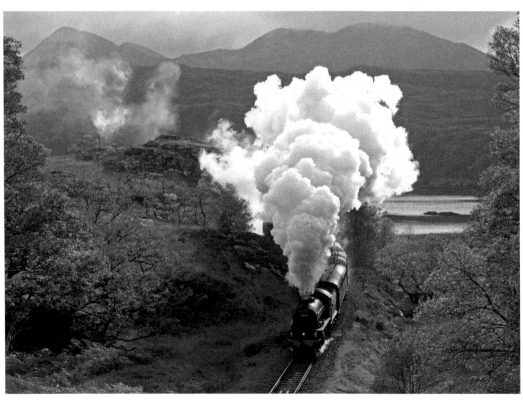

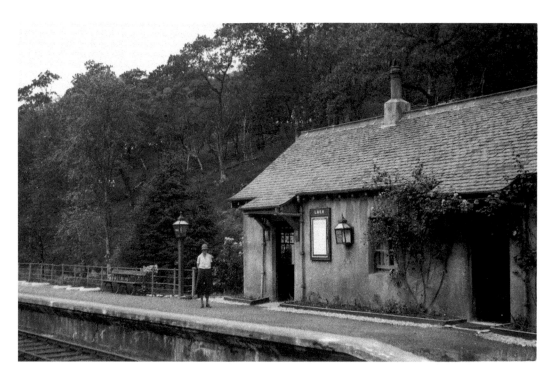

The gradient eases through Beasdale station (seen in LNER days), at first a semi private facility for Arisaig House.

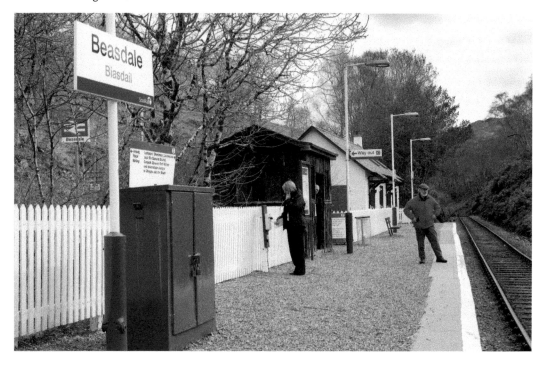

Beasdale survived the uncertainties of the 1960s, but in woeful condition. Its later transformation is pleasing. (*McNab*)

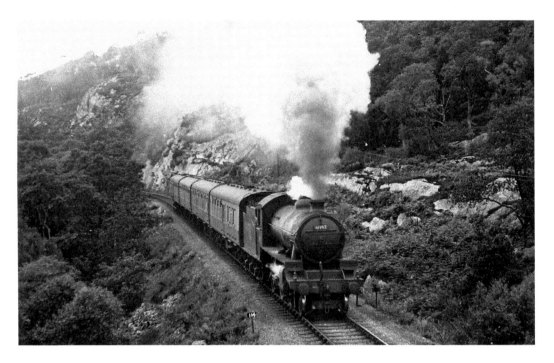

61997 *MacCailin Mor*, the K4 rebuilt as K1 prototype, heads a Mallaig–Fort William train near Beasdale in the mid-1950s.

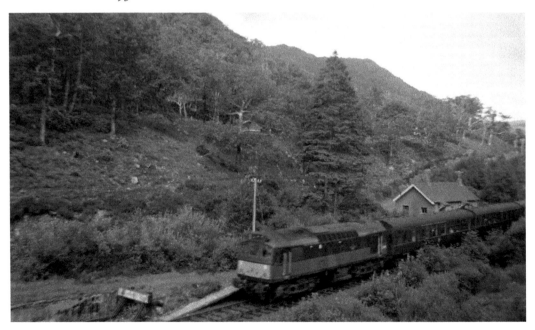

Domination of both the West Highland proper and the Extension by BRCW Sulzers (class 27) would become near-total, once they had seen off the unreliable NBLs (see p.45); but other Type 2s occasionally featured (see p.50). A 'Derby Sulzer' in two-tone green (class 25) takes a down train past Beasdale in 1966 – perhaps doing the summer duty given in previous years to a class 20. (*Spaven*)

From salt-water Loch Eil to salt-water Loch Ailort is a lengthy 'hop'; that to Loch-nan-Uamh is short and swift. The final 'hop' to the sea at Arisaig features Beasdale bank and the ensuing descent by Borrodale, where the castellated viaduct, immediately west of the final tunnel, is the least accessible but perhaps the most interesting on the line. The bold arch was exceptional at the time of building and the structure has a pronounced batter.

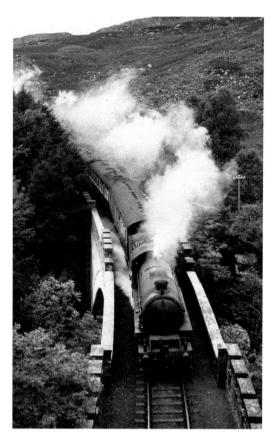

37 688 approaches Arisaig with a ballast working in March 2012, crossing Larrichmore viaduct. Alongside is the transformed A830. (*Henshaw*)

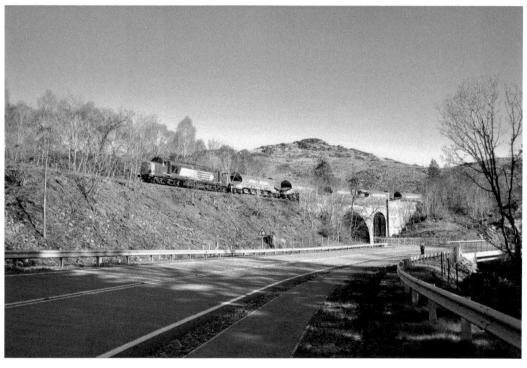

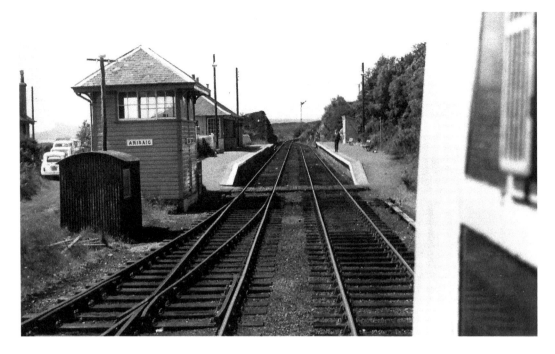

Arisaig of the 1960s, little changed over half-a-century (though the signals have become 'upper quadrant'), is seen from a departing up train. The Board of Trade dispensed with foot-bridges at the side-platform passing stations on the Extension; crossings at the platform ends were judged sufficient. (*Yuill*)

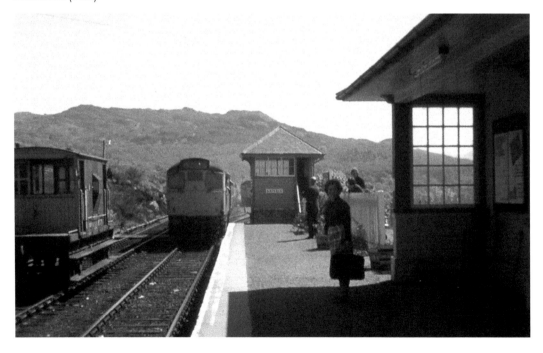

A class 27 approaches on a down train in the summer of 1977, while another, on engineering duties, shunts in the background. (*Frank Spaven Collection, courtesy D. Spaven*)

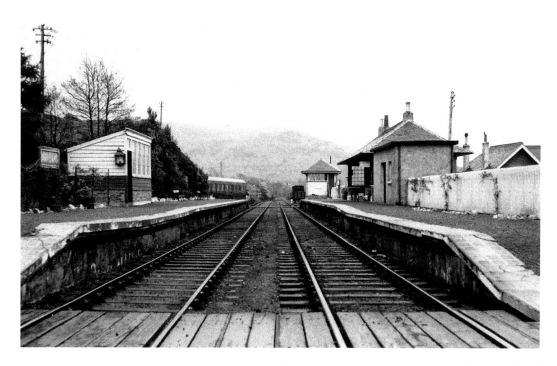

The view looking east at Arisaig
includes a camping coach. (*Stevenson*)
Converted vehicles allocated to the
Extension included old Pullmans and
'semi-royals' with clerestory roofs and
six-wheel bogies.

A down Sprinter calls in June 2012,
with Arisaig bay in the background.
(*Crawford*) Arisaig is the most
westerly station on the British
mainland. That it belonged for a
quarter of a century to the London &
North Eastern Railway always seemed
a contradiction.

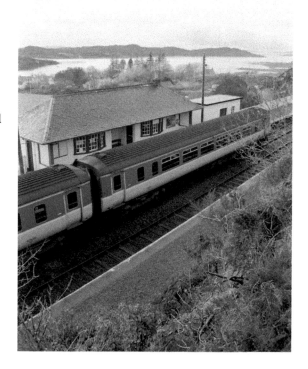

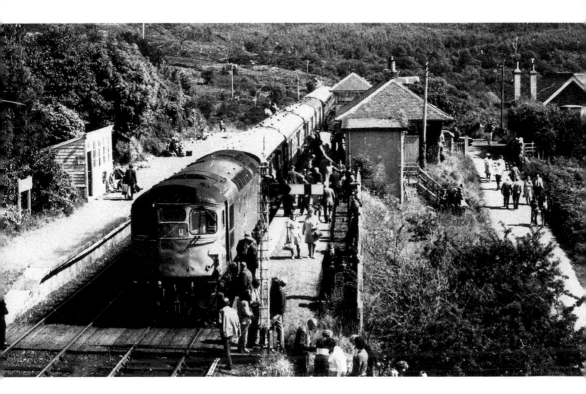

A Scottish Railway Preservation Society excursion waits to cross an up train at Arisaig. (*Stevenson*)

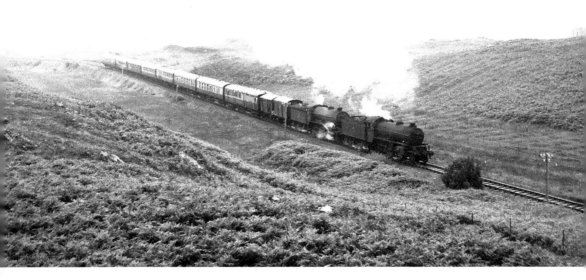

Turning east and north, the line dips by Kinloid. A K1 with K2 pilot (cf. page 49) has the afternoon Mallaig–Glasgow, with two fish vans behind the engines. The train is climbing to Arisaig.

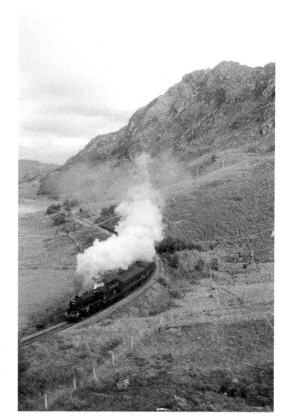

A Black 5 lifts the up Jacobite to Kinloid and Arisaig in September 2005. (*Crawford*)

For many travellers the craggy Rough Bounds between Glenfinnan and the western sea are the essence of the Extension; but its forty-odd miles include the Loch Eil seashore and the passage of South Morar by Keppoch Moss. Ahead of 62005, the line stretches across the Moss. (*Henshaw*)

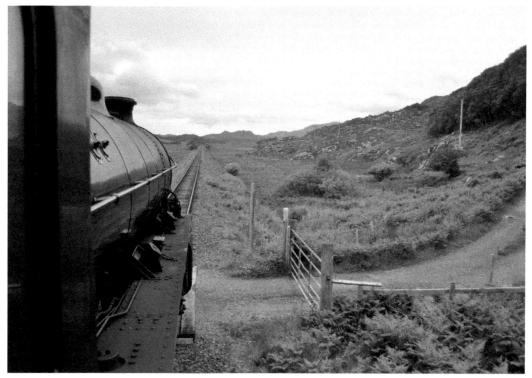

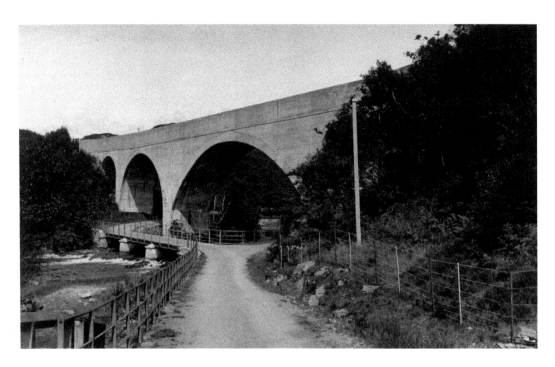

At the Falls of Morar, the viaduct was designed to straddle river and road. (*Alsop*) The modernised A830, by passing Morar village, now strides uncompromisingly across Morar bay. Access by sea – to Loch Eil, Loch Ailort, Loch-nan-Uamh and Morar – shaped the building of the Extension.

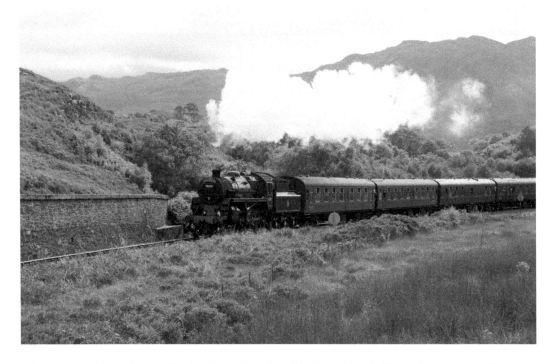

76001 appproaches Morar with the down Jacobite. (*Mathieson*) Loch Morar lies in the valley behind; the River Morar, which the train has just crossed, drops to the sea in less than a mile.

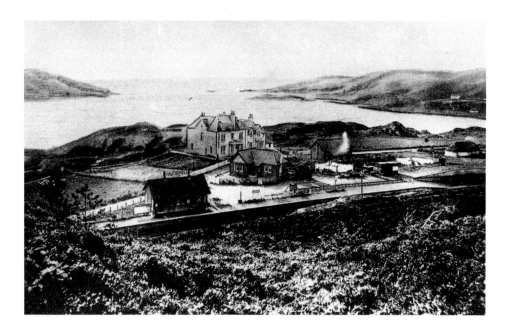

Morar station building is basic (cf. Beasdale on p.73). The original van-body store can be seen. Other single-platform stations (Banavie, Corpach and Locheilside) were given the Extension's standard 'modified chalet' building, akin to those on the West Highland proper.

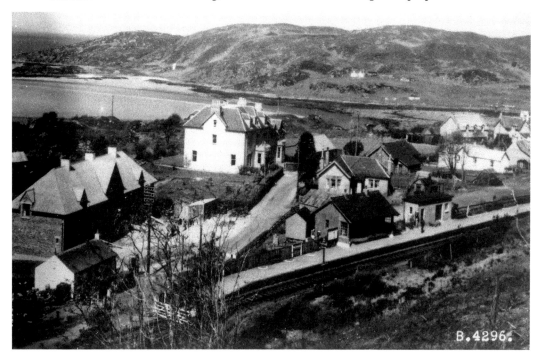

A 1950s view shows Morar's modest expansion over half a century. The main road (as then was) cuts the railway obliquely, with the level crossing gates (bottom left) positioned to fit. (*Stevenson*) In the background of both photographs is Morar bay, noted for its white sands.

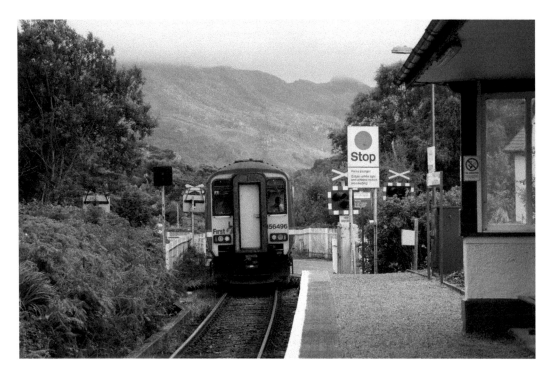

An up Sprinter negotiates Morar's modernised level crossing in August 2010. (*McNab*) When Extension stations were first unstaffed, train crews set the old gates against road traffic and, having passed through, resecured them against the railway.

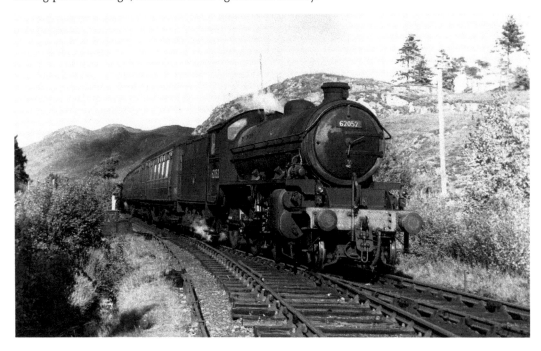

K1 62052 heads an up train in November 1960. Morar's short siding (seen on p.81) regularly held a camping coach.

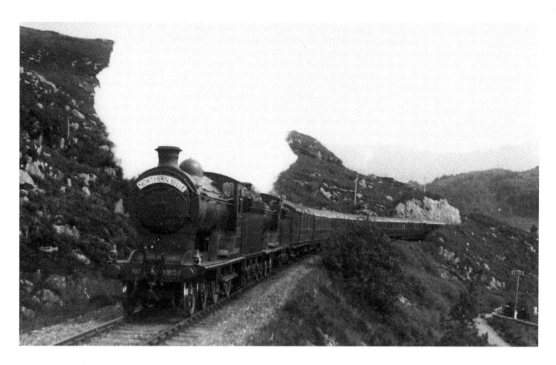

Two Glens take the day coaches of the Northern Belle out of Morar on the last miles to Mallaig. The leading engine is LNER 9256 *Glen Douglas* – preserved today in North British condition as 256. (*Yuill*)

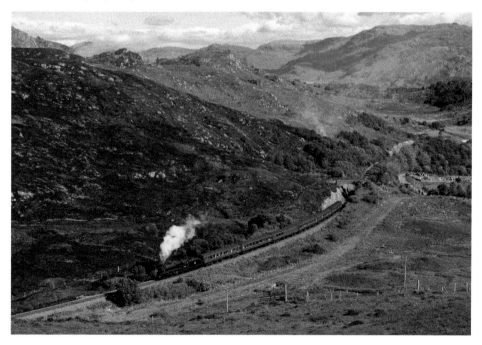

Black 5 44871 climbs out of Morar in June 2012 with the first afternoon Jacobite of the 2012 season. Loch Morar is in the distance. (*Fielding*) Grass fires were once a familiar hazard; the appropriate precautions had to be re-learned when steam returned.

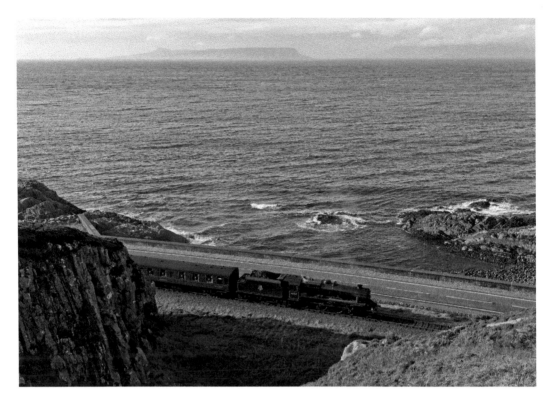

Though Loch-nan-Uamh opens to the sea and Arisaig offers a coastal panorama, only on the final approach to Mallaig, past Glasnacardoch, does the Extension touch the Atlantic shore. Black 5 45407 arrives with the last Jacobite of the 2011 season. (*Fielding*)

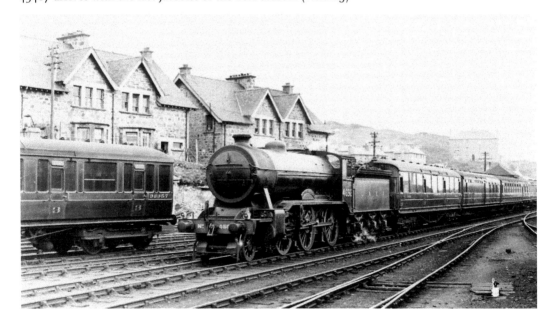

6392 *Loch Eil* (subsequently 1782 and BR 61782) brings the morning train ex-Glasgow into Mallaig in June 1937. The scene is entirely LNER, the time midday. (*H. C. Casserley*)

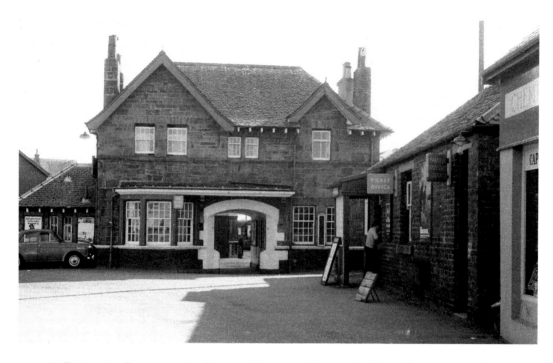

Mallaig station house, seen in the 1950s (*Stevenson*), has survived into the Sprinter era (*Furnevel*). The upper storey was designed as the stationmaster's flat.

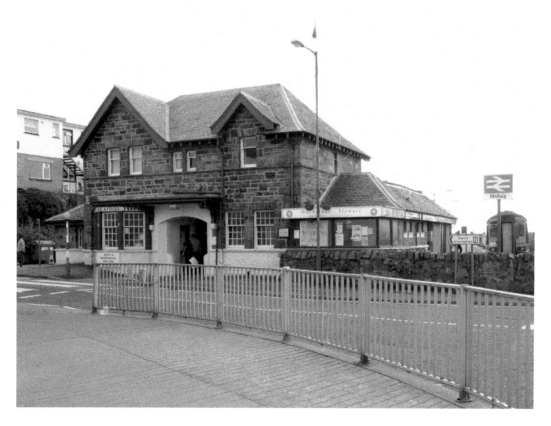

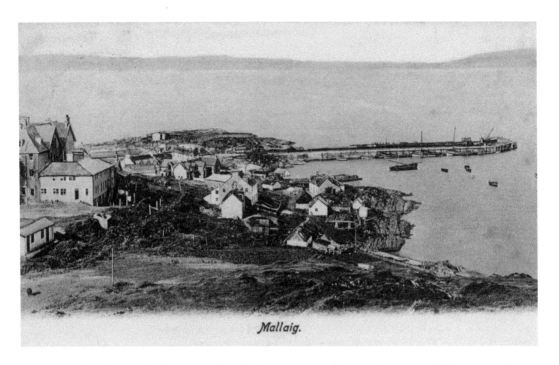

Mallaig.

As this early photograph shows, Mallaig harbour was neither spacious nor fully protected from a northerly fetch. (*Mallaig Heritage Centre*) From about 1905 enlargement, with an outer breakwater, was repeatedly urged – something which neither the North British Company nor the LNER would entertain on their own account.

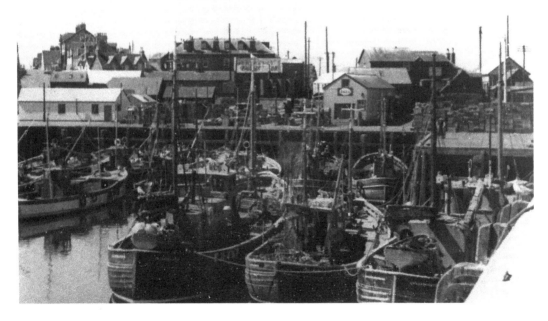

In the 1950s, traditional fishing and ancillary services still flourished. (*Stevenson*). There was, on occasion, little room for private vessels. (In the earliest years landowners wanted priority for their yachts, causing some friction.)

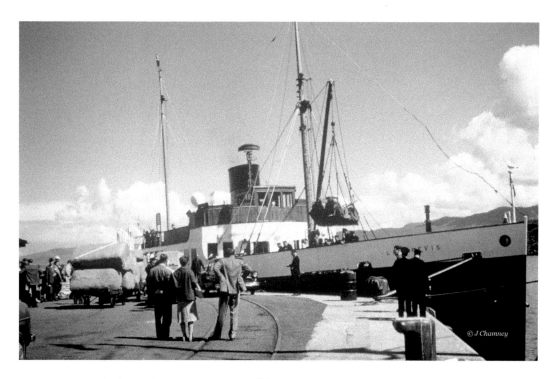

MacBrayne's diesel-electric *Loch Nevis*, well-known at Mallaig on the Portree run, was a mail vessel with cargo space. (*Chamney*) Skye and Lewis sailings had other rail connections at Kyle of Lochalsh; the middle ports of the Outer Hebrides were served from both Oban and Mallaig. In steam days, of the three rail routes to the Islands, the West Highland displayed the most varied locomotive-power.

K2 61775 *Loch Treig* provides the backdrop for a typical Mallaig group. (*Stevenson*)

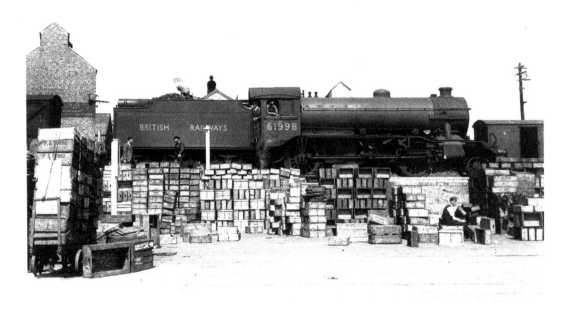

K4 61998 *MacLeod of MacLeod* has brought in the morning Glasgow–Mallaig. Arriving engines, once detached, went forward to the pier, then reversed by the outer road, behind the wall which sheltered the station on the west, reversing again to gain the shed.

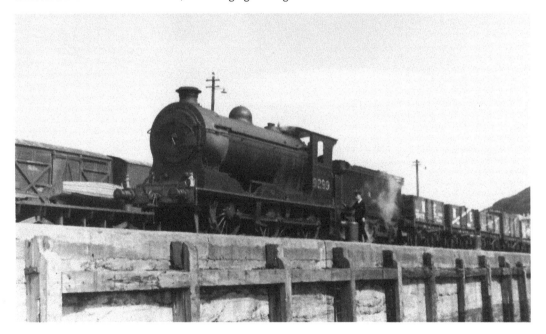

Conceived as a centre for short-range sail boats, Mallaig would serve steam trawlers and drifters, supplanted in turn by diesel craft. Coal and fuel oil added to railway revenue. Ex-NBR J37 (LNER 9299) shunts on the pier-cum-breakwater, with coal wagons in the rake. (*Yuill*)

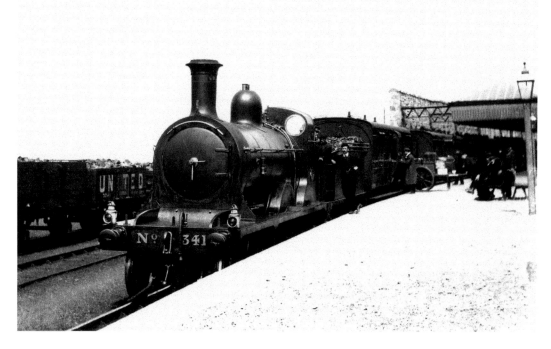

West Highland Bogie NBR 341, preparing an up train, shunts at Mallaig station. (*Lynn*)

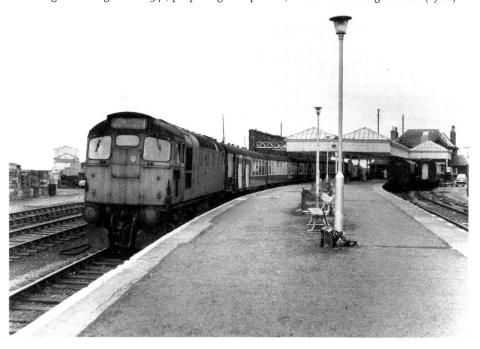

D5356 (class 27) heads the afternoon Mallaig–Glasgow in April 1971. The Mark 1 set is characteristic of the then winter timetable – two compartment brake-seconds, compartment composite and buffet-restaurant. (*Author, courtesy late D. Cross*) At Fort William, it will become the 'West Highland Sleeper'; more precisely, it will add the overnight 'London portion'.

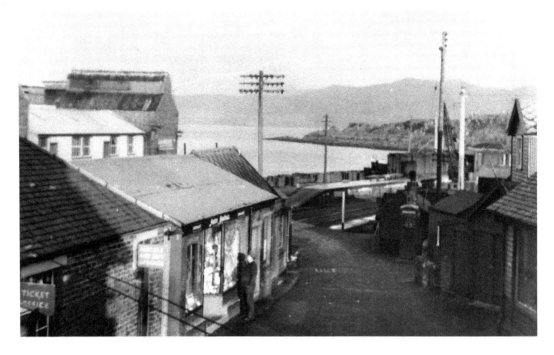

On the short walk from station to pier, something of Mallaig's early 'shanty town' appearance, the consequence of unregulated development on an exposed yet constricted site, lasted into the 1950s. One of the steam cranes can be seen on the right. (*Stevenson*)

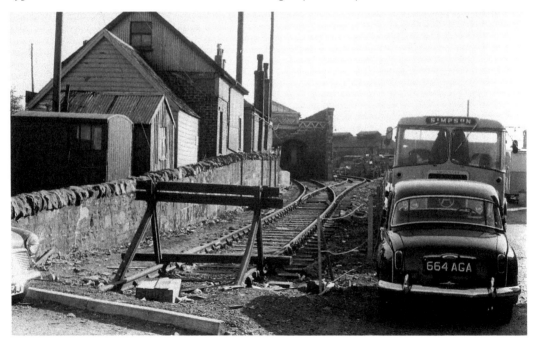

With fish traffic much reduced and eventually abandoned, the through road to the pier was cut back, leaving sufficient track to release a locomotive. (*Stevenson*) The western wall has since been demolished, but a run-round remains.

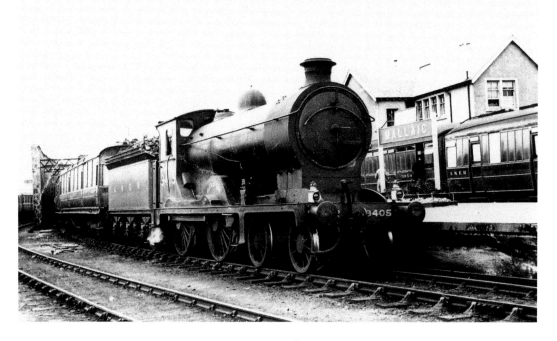

D34 9405 *Glen Spean* heads a Mallaig–Fort William train, a relief for the afternoon Mallaig Glasgow, in June 1937. (*H. C. Casserley*)

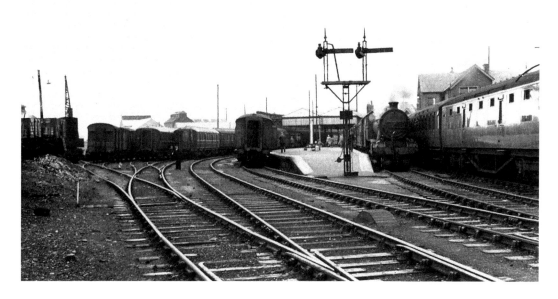

Mallaig seems filled to capacity in September 1949. The engine seen head-on is K4 61994 *The Great Marquess* (see also p.53). Another steam cranes completes the line-up (left). (*Stevenson*) The lower-quadrant semaphores are prominent (cf. their replacements on p.93 and p.95).

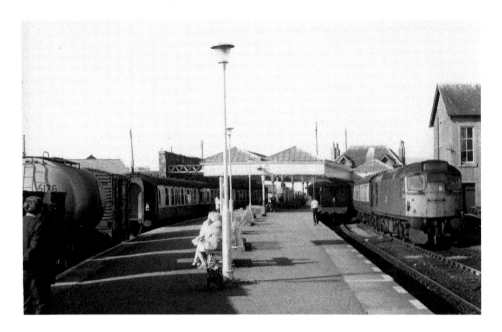

When the Extension escaped closure in the 1960s, Mallaig station on the face of things continued much as before (though the latest mixed workings – see p.45 – are in evidence). (*Stevenson*). The end of fish traffic told a different tale and more economies were on the way.

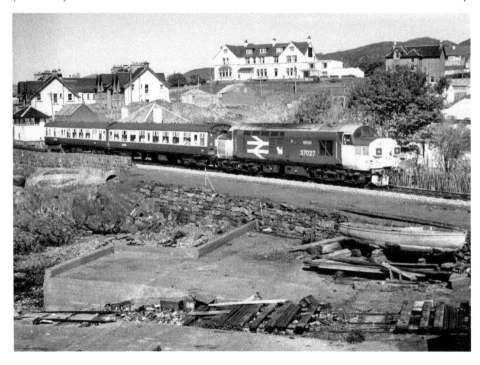

37 027 *Loch Eil*, with terrier logo prominent, takes two well-filled Mark 1s out of Mallaig in May 1985. (*Noble*) Open stock, traditionally a summer feature, ran year-round on the West Highland in the last years of locomotive-hauled passenger trains, when compartment coaches were everywhere on the way out.

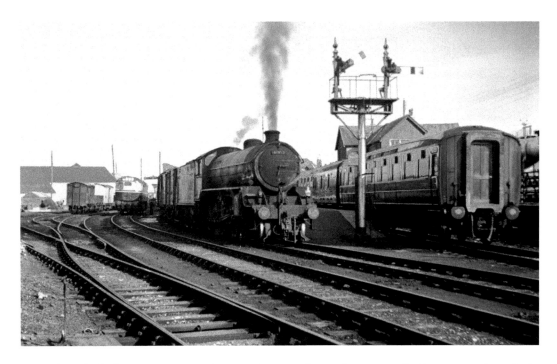

Though Black 5 4-6-0s now perform on the Extension each summer, the line was a 2-6-0 redoubt from Nationalisation till the end of BR steam. B1 4-6-0s latterly made inroads, taking over the Extension goods, but vanished before the last K1s. In February 1962 B1 61352 heads the afternoon Mallaig–Glasgow – plus fish vans. The lurking BRCW Type 2 in two-tone green is as yet without yellow warning panels. (*Chamney*)

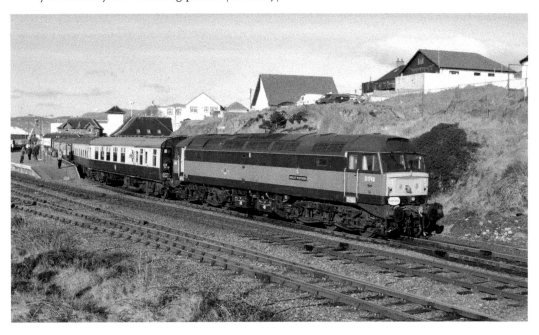

Preserved D1748 *Great Western* (Class 47) waits at Mallaig with the Pathfinder Tour of Scotland in April 2010. (*Henshaw*)

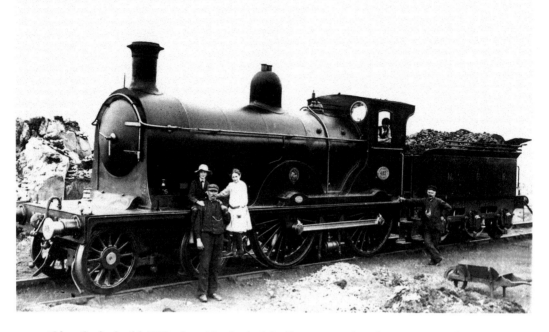

Abbotsford-rebuild NBR class M 487 (originally *Montrose*) makes an unusual visit to Mallaig. (*Lynn*) Despite their large driving wheels, these long-lived engines usefully supplemented the over-taxed West Highland Bogies between Glasgow and Fort William, pending the development of Intermediates and Glens.

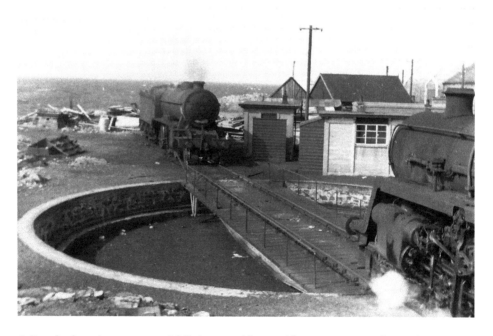

A Standard 4 2-6-0 eases onto Mallaig turntable on a blustery, overcast day in the summer of 1960. In the background is the choppy Sound of Sleat. (*Stevenson*)

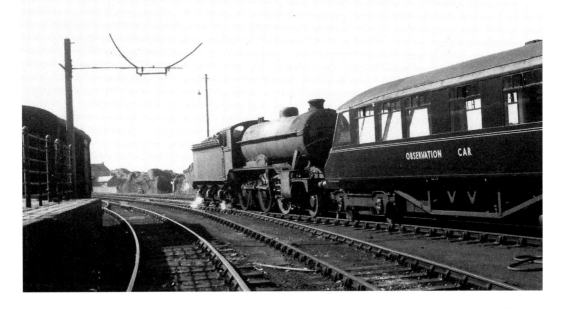

The Extension observation car, its viewing end modified (ct. p.12), has arrived at Mallaig in September 1959. The train engine, having run round, performs the necessary shunting. (*Yuill*)

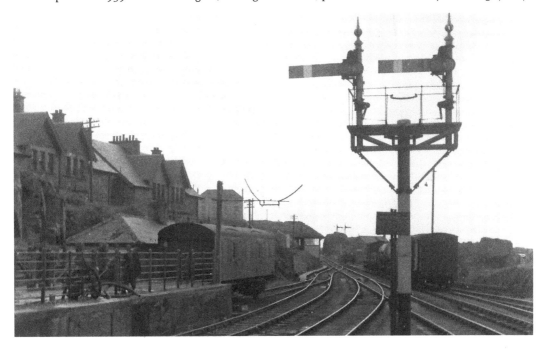

Past the final cutting, all the tracks at Mallaig fanned out from the single 'main'. Seen from the platform end, the loading bank bay is on the left, the entry to tuntable and shed on the far right. (*Stevenson*) The upside-down loading gauge in both photographs is a mystery.

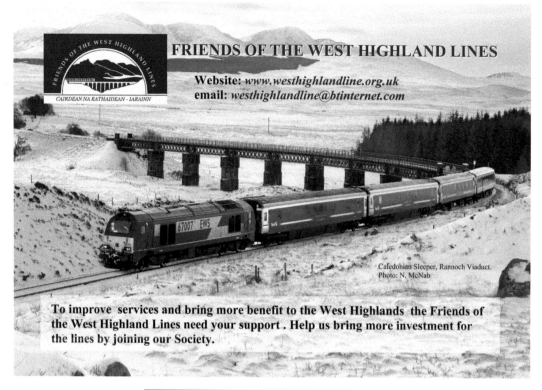